HAND DRAWN BY

SASKJA COOK

What better way to relax than to colour.
Whether you're looking for a way to unwind or a new hobby, colour therapy has been proven to be an effective stress management technique.

I love to draw and I love to see my pieces brought to life by each colourists unique take on them. Each piece is a collaboration between us, my drawing and your colouring.

Please feel free to share any finished pieces on:

www.facebook.com/sassycolouring

Copyright © Saskja Cook 2017. All rights reserved. No part of this book may be reproduced, stored in a retrieval system, or transmitted in any form or by any means, without the prior permission in writing from the author, nor be otherwise circulated in any other form of binding or cover other than that in which it is published and without a similar condition including this condition being imposed on the subsequent purchase

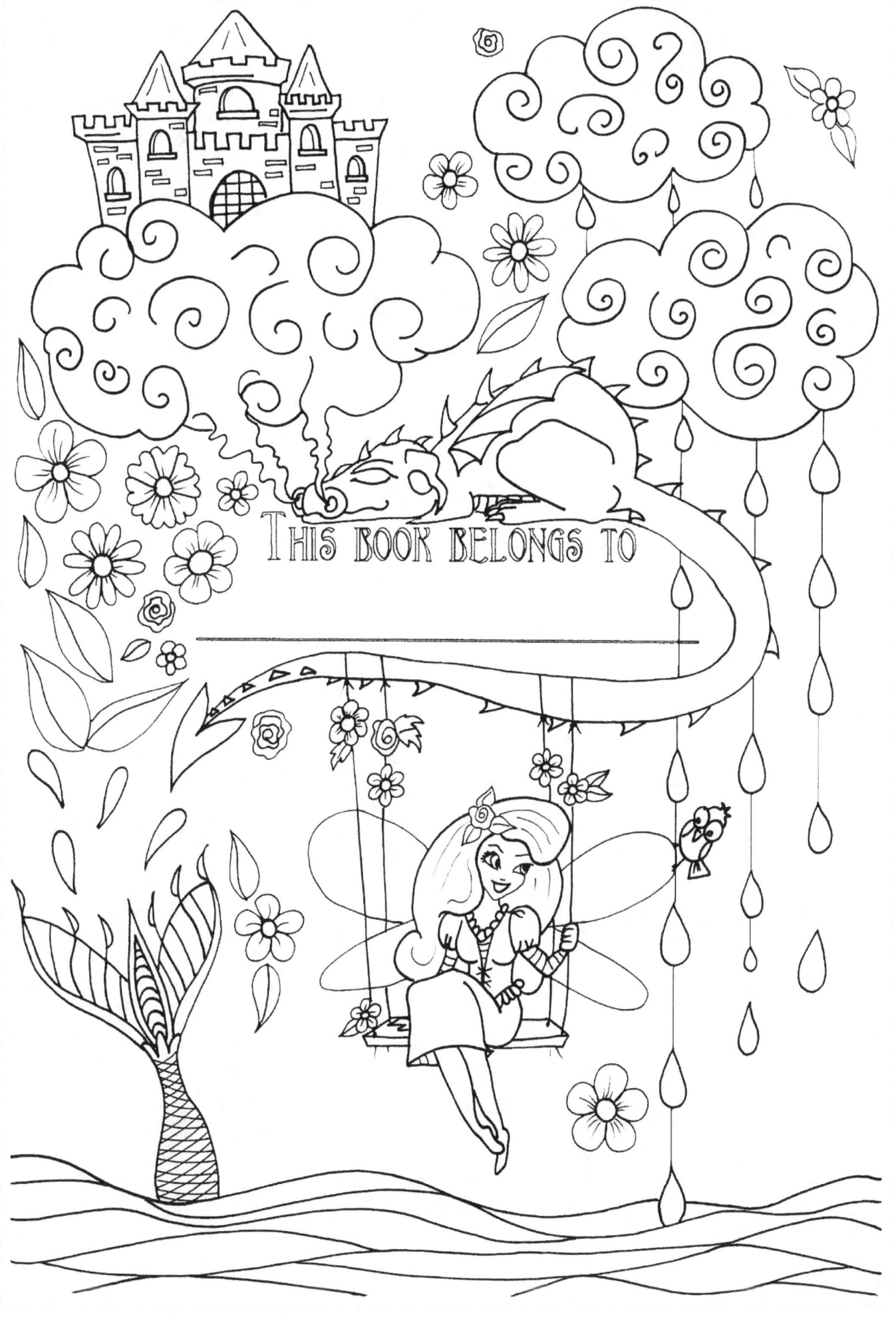

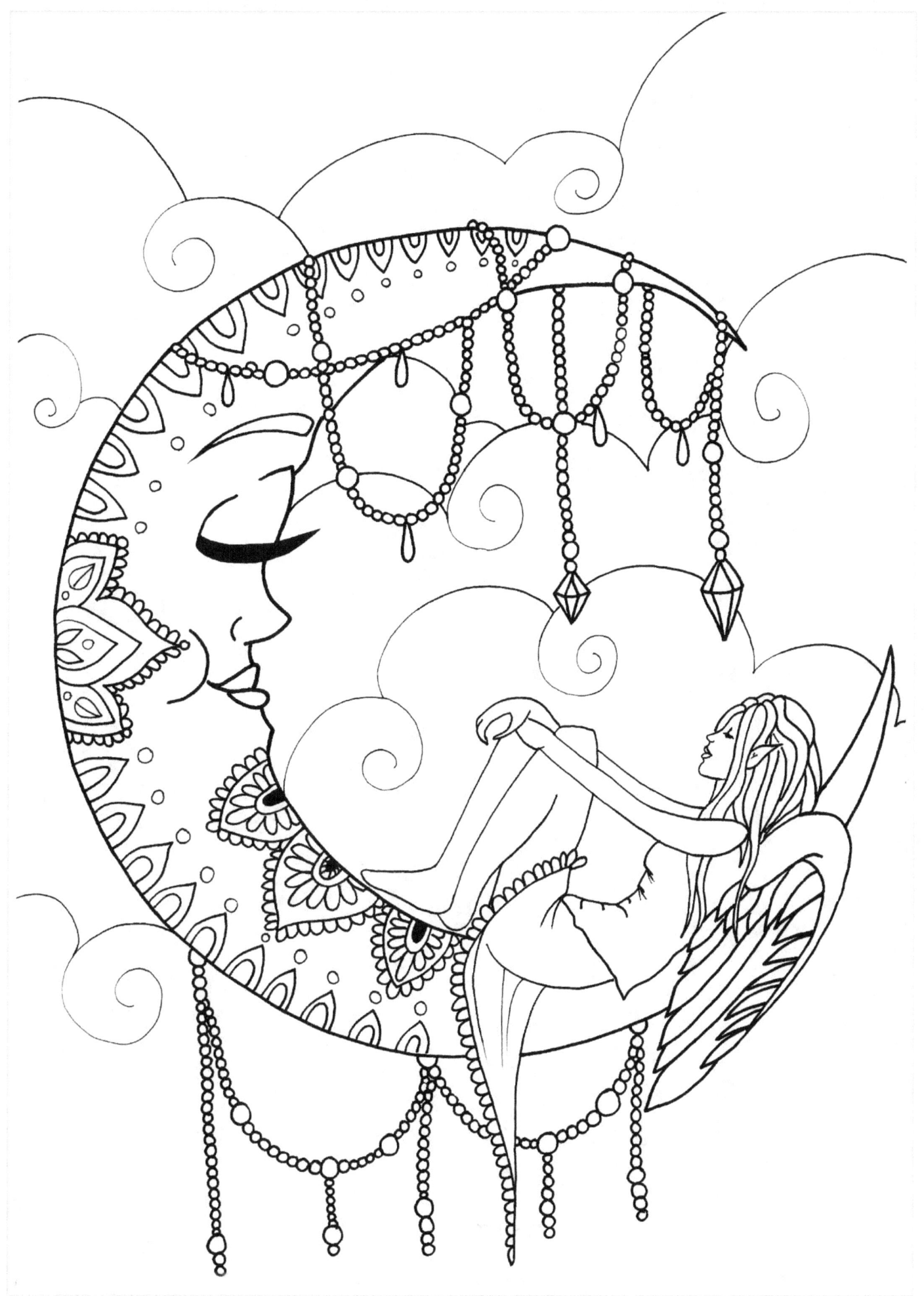

'Bed Time'

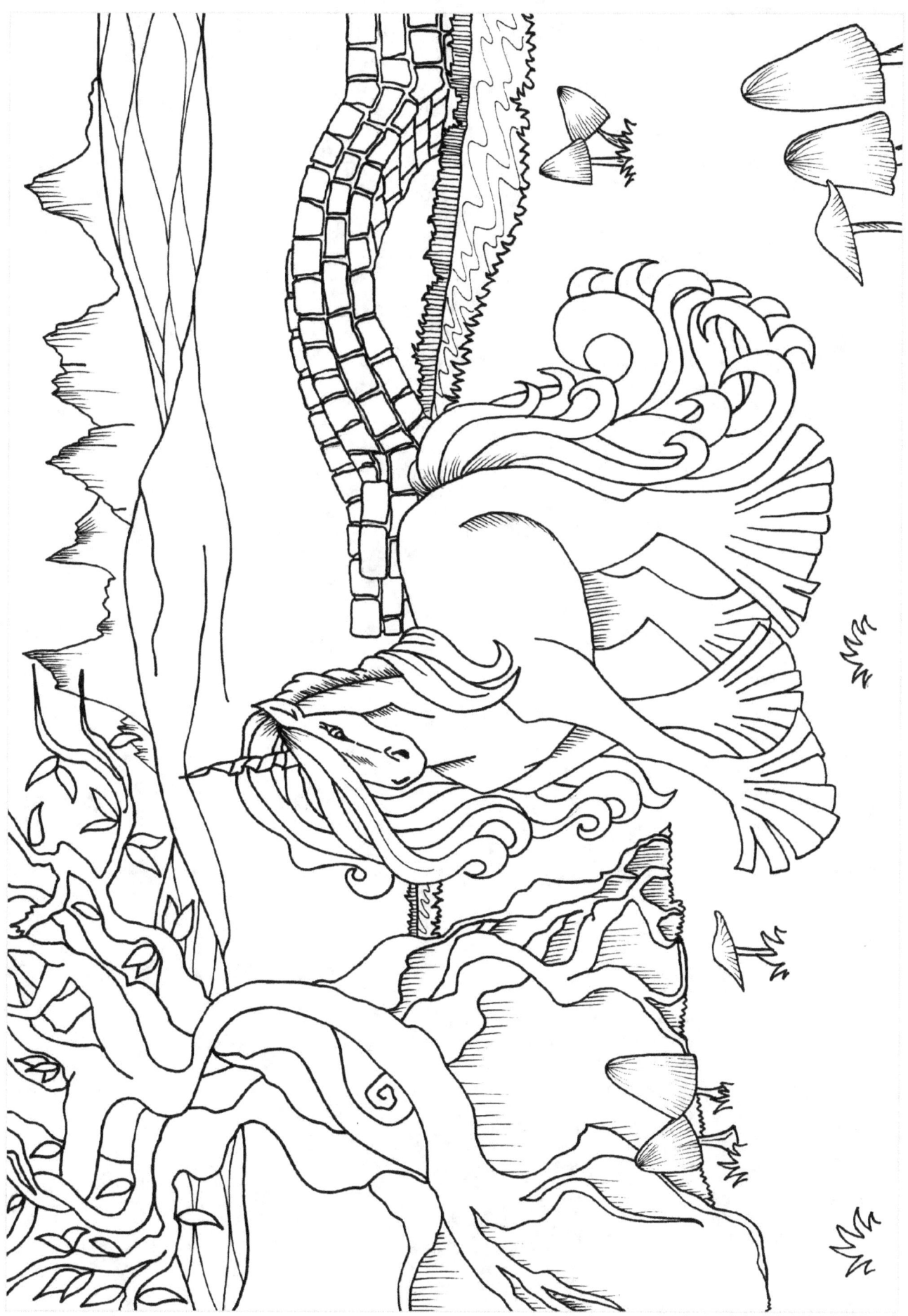

'In the Field'

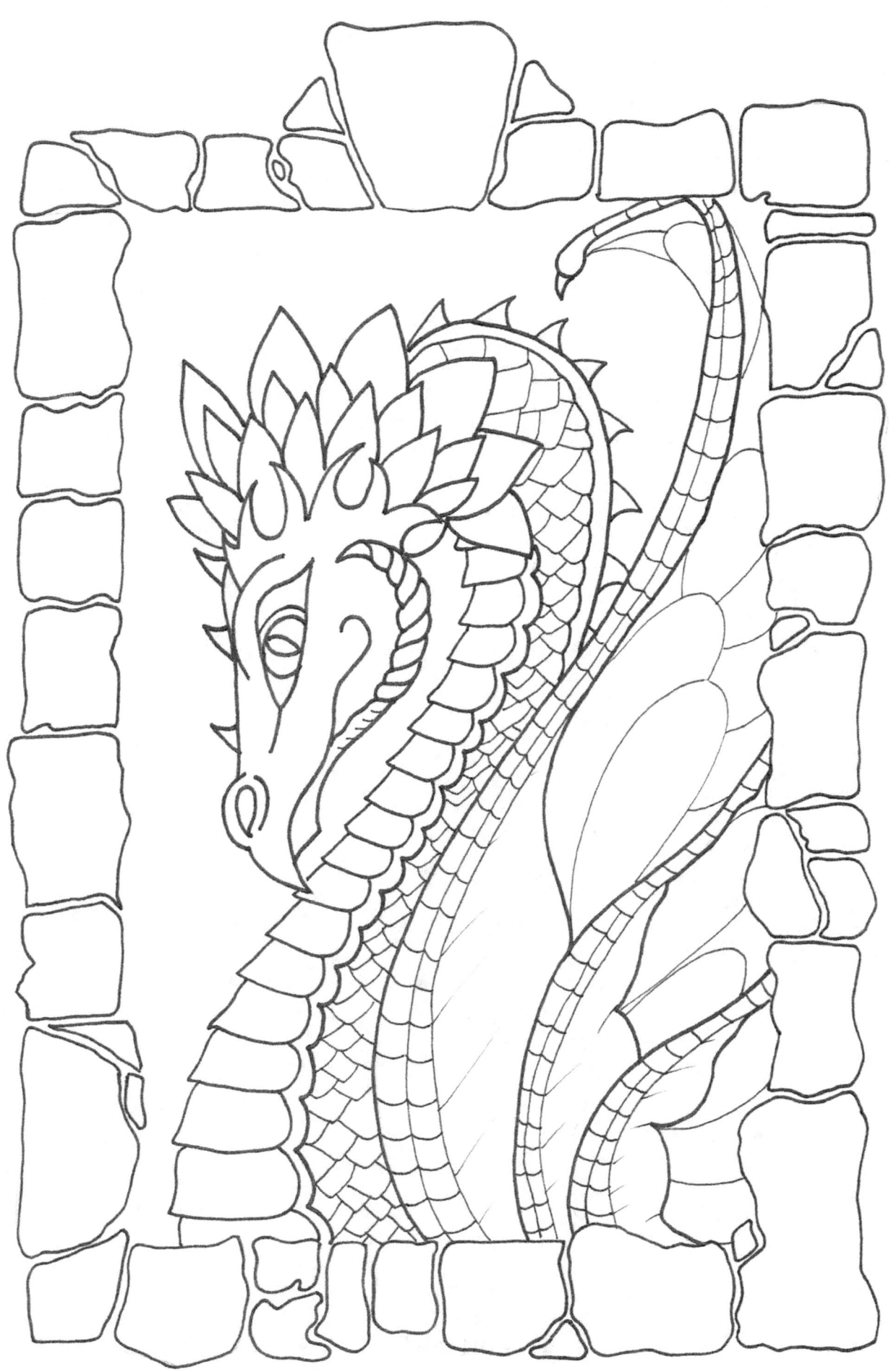

'Portrait'

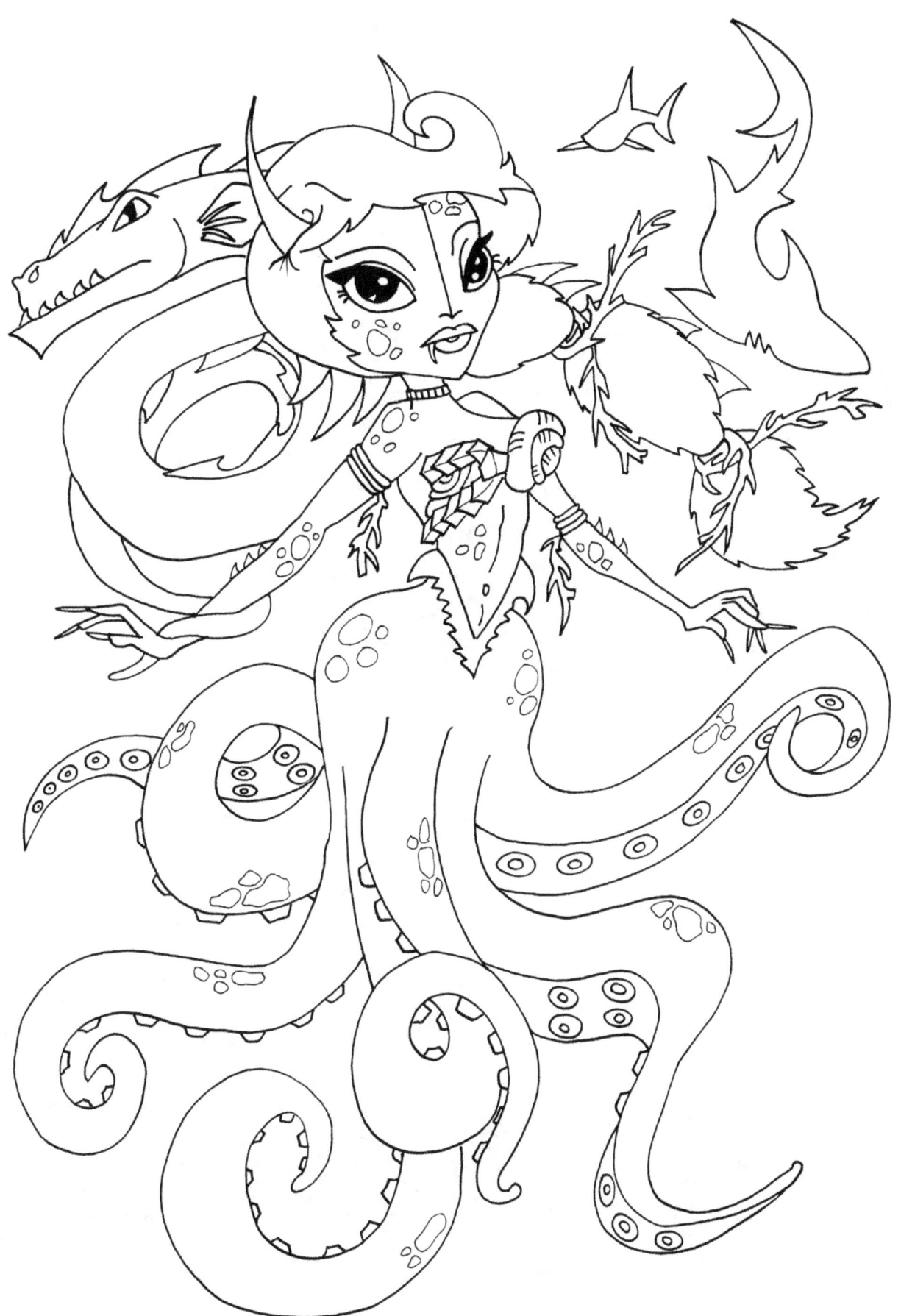

'Sea Witch'

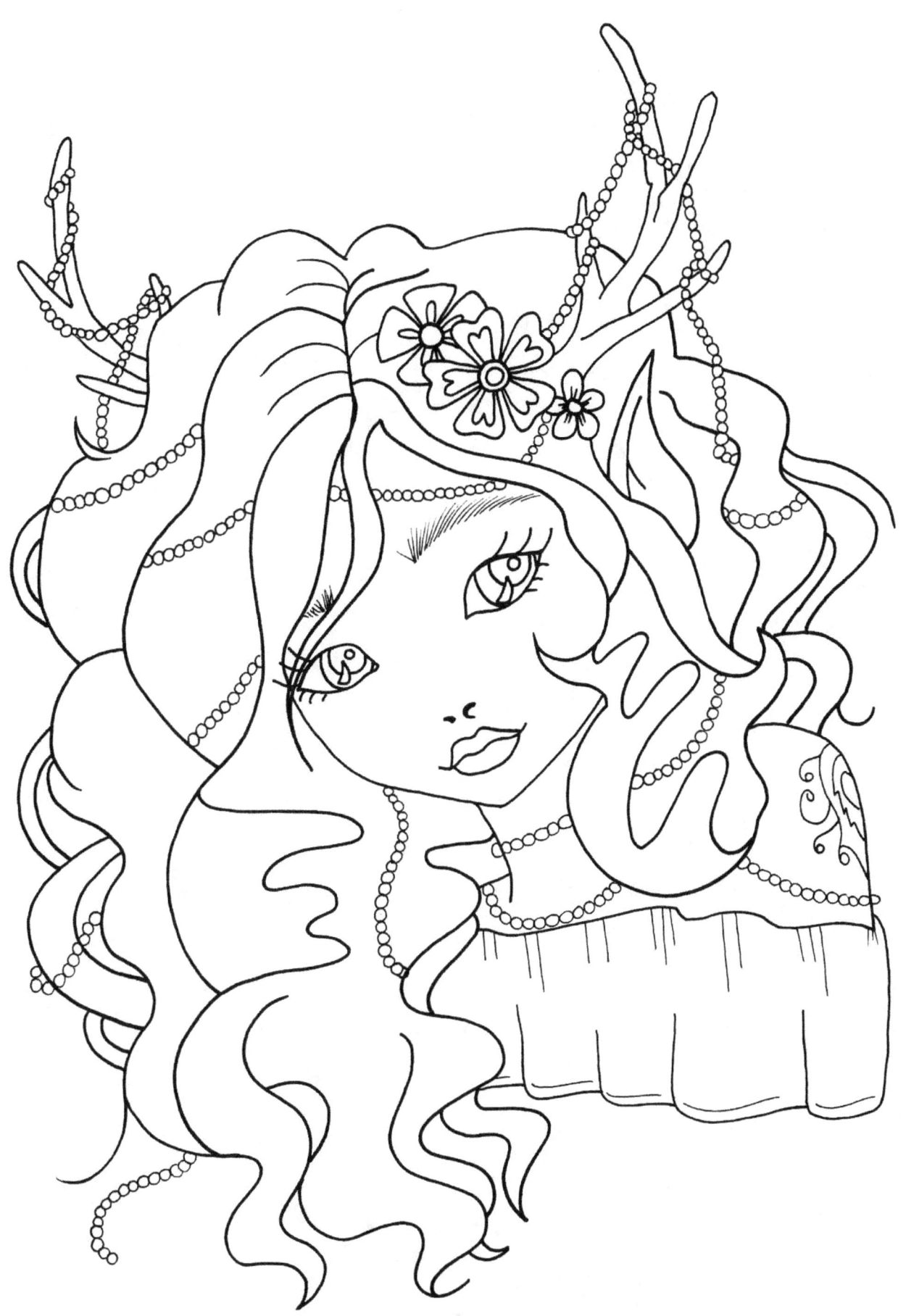

'Taz'

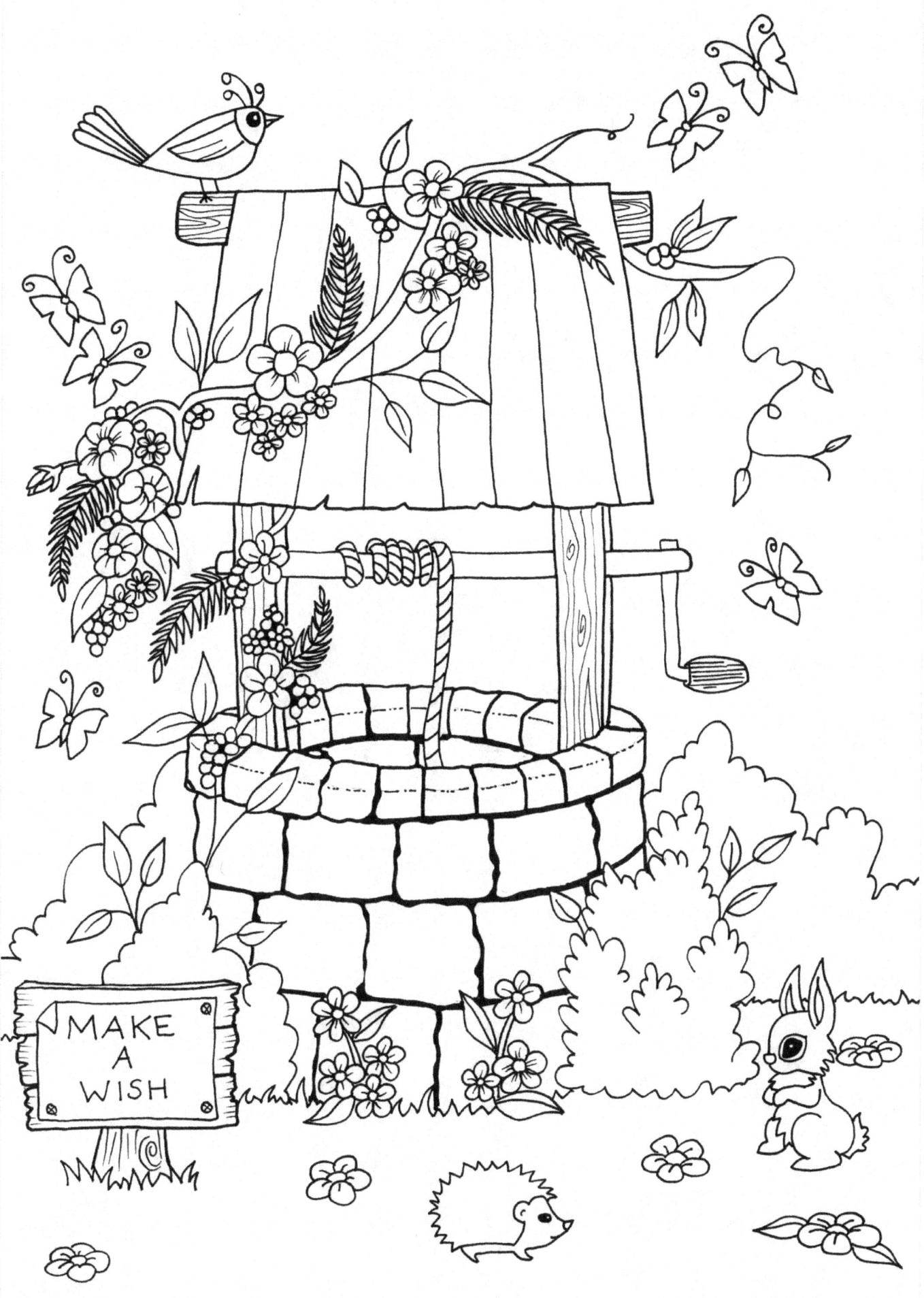

'Make a Wish'

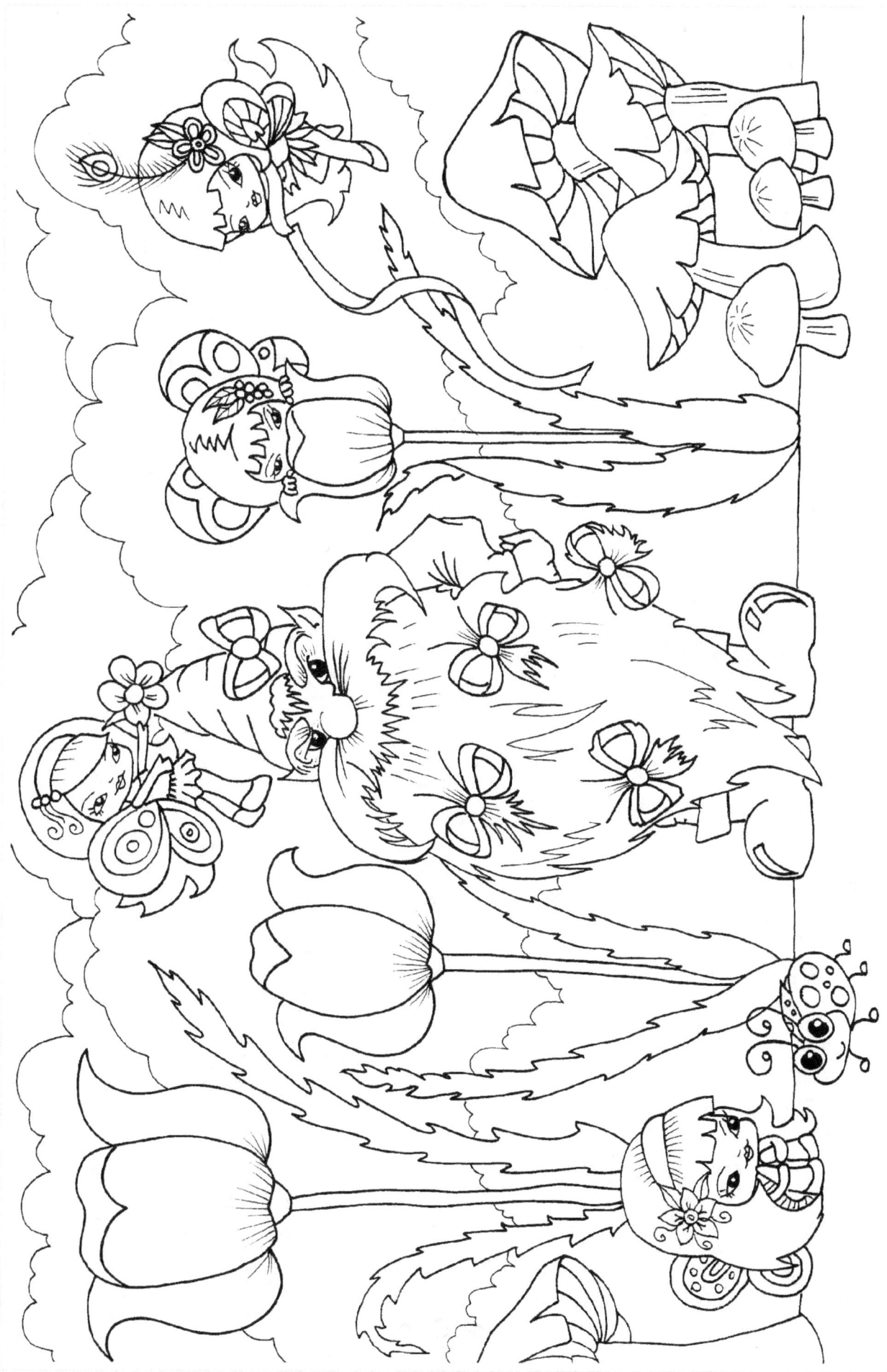

'Make Over'

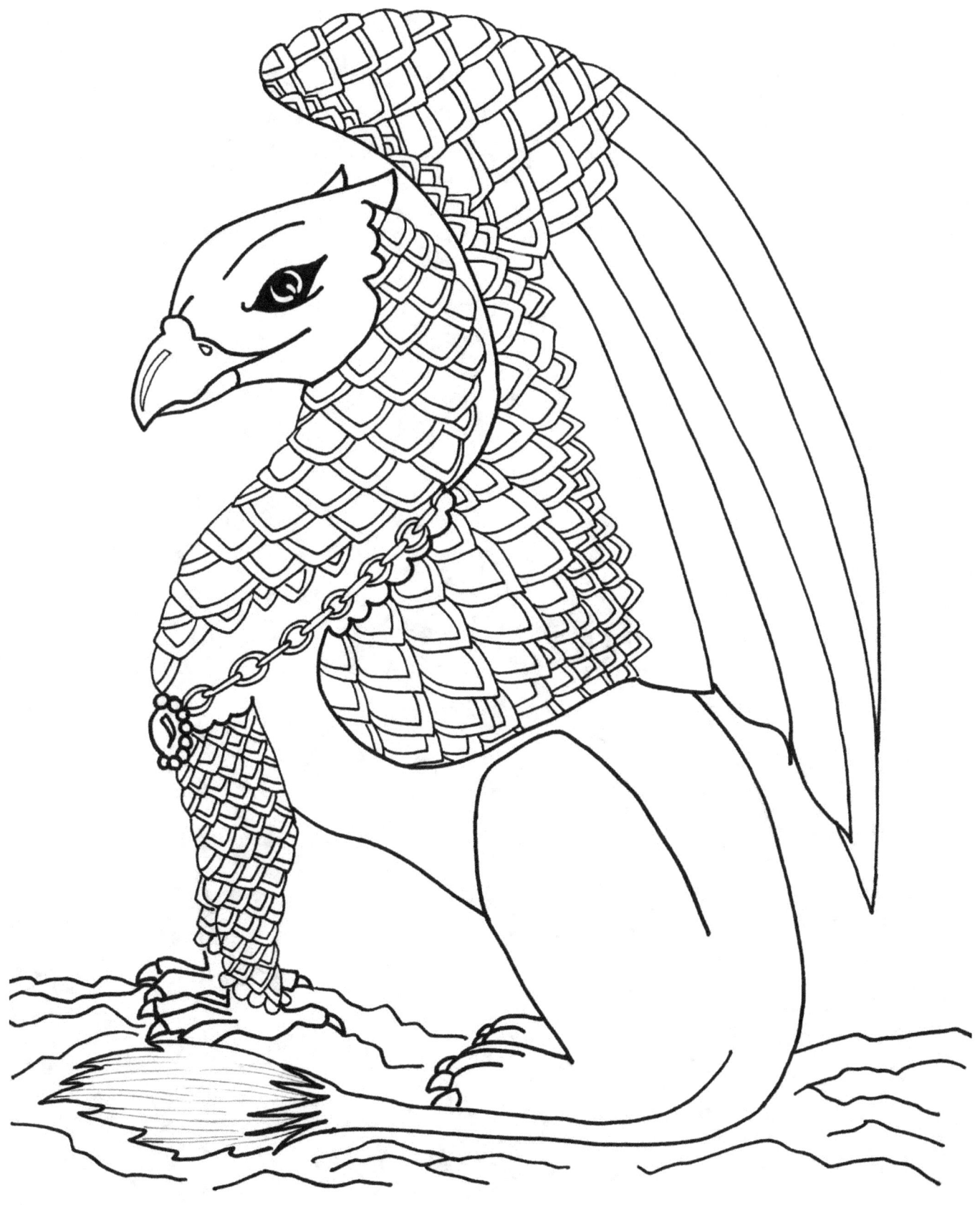

'Griff'

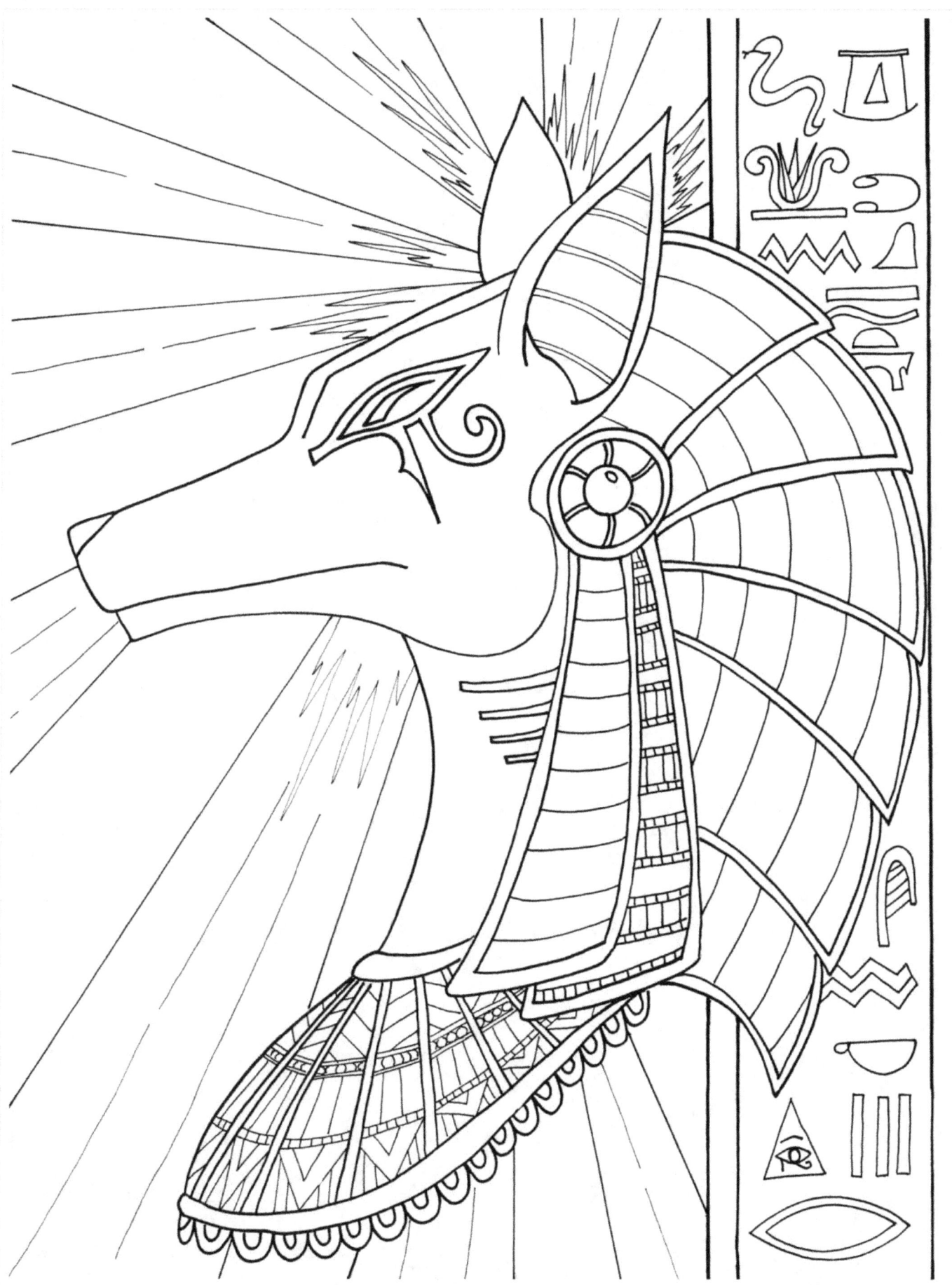

'Anubis Bust'

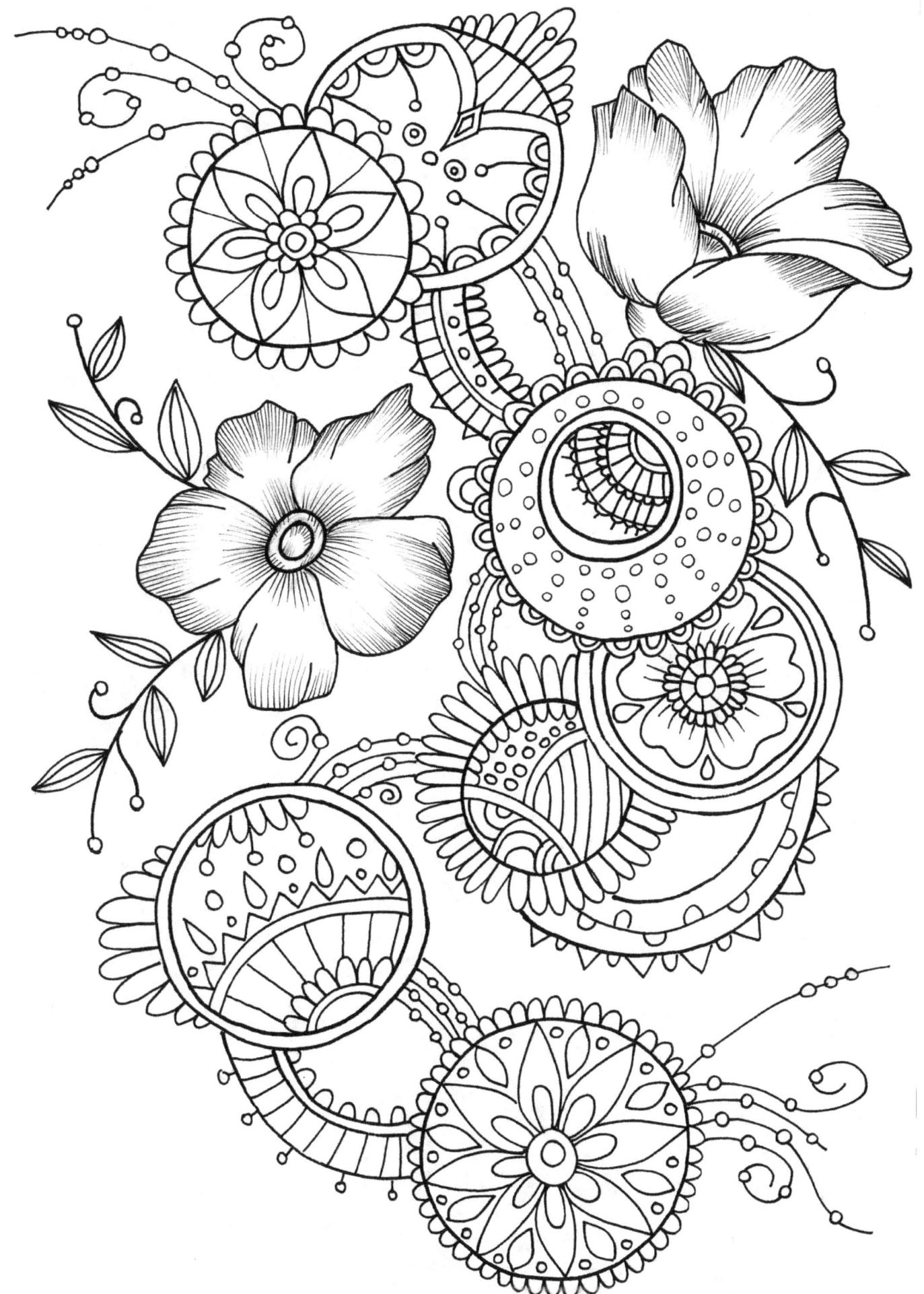

'Flower Flurry'

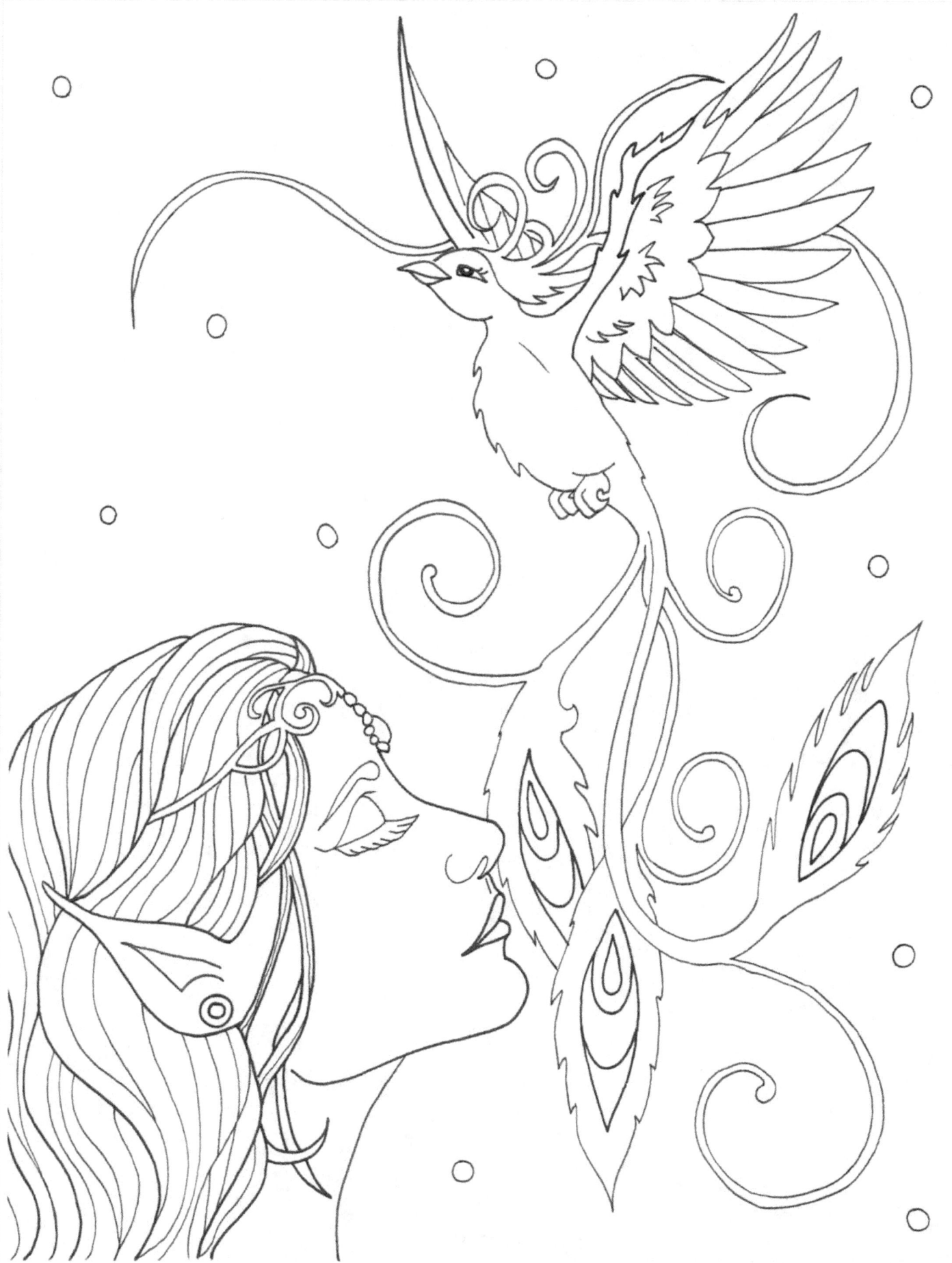

'Bird Gazing'

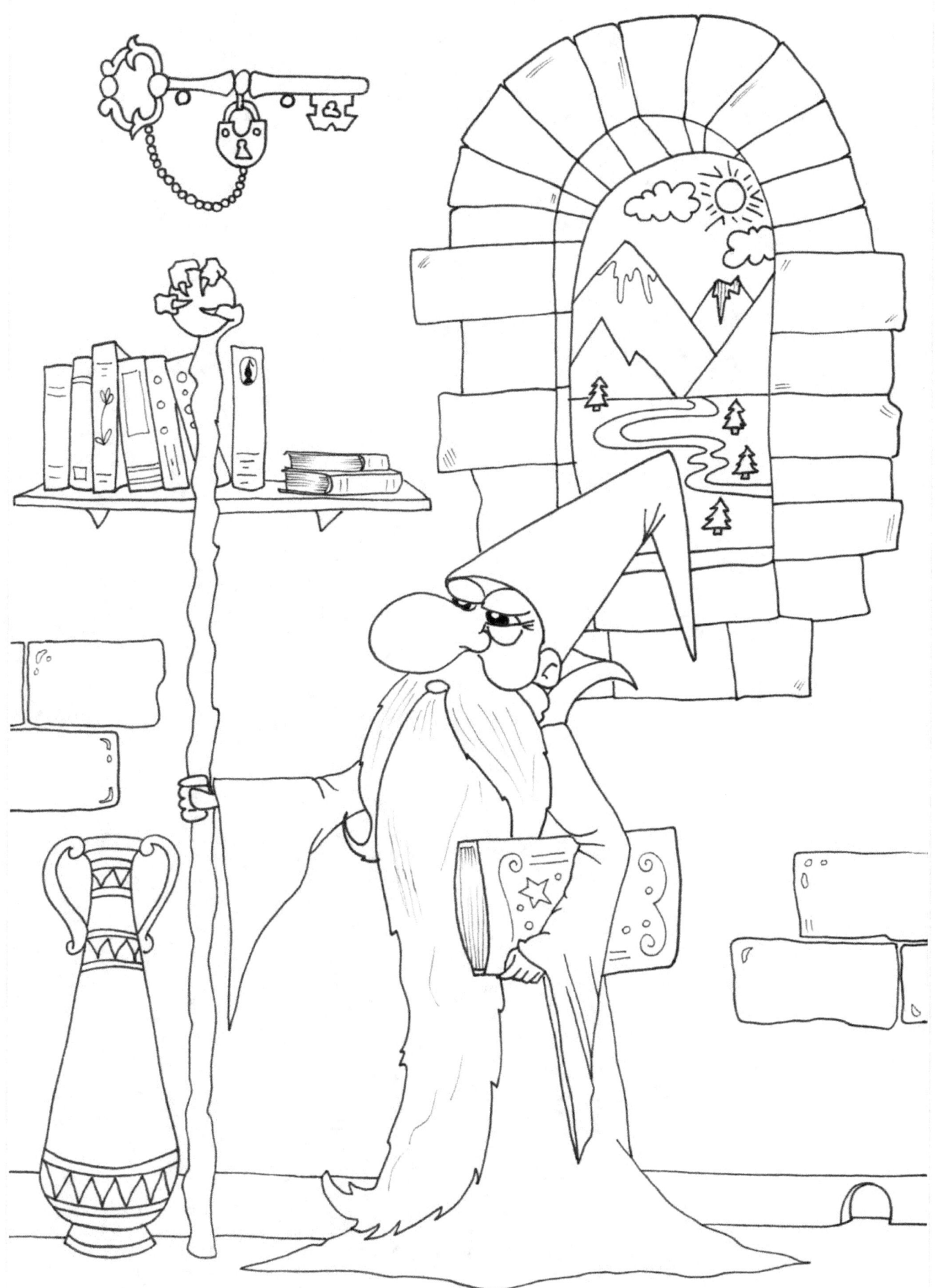

'Work to be Done'

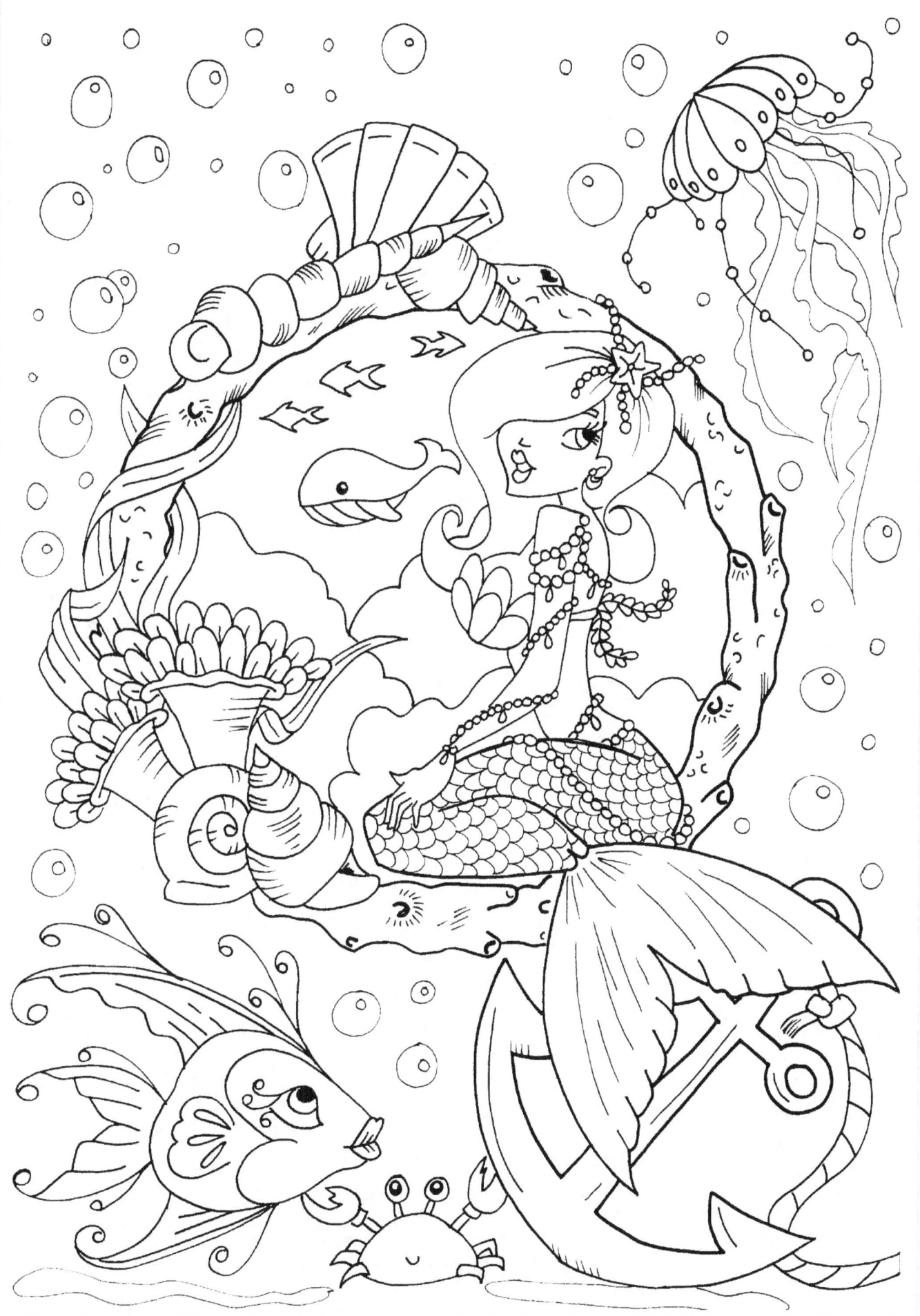

'Sea View'

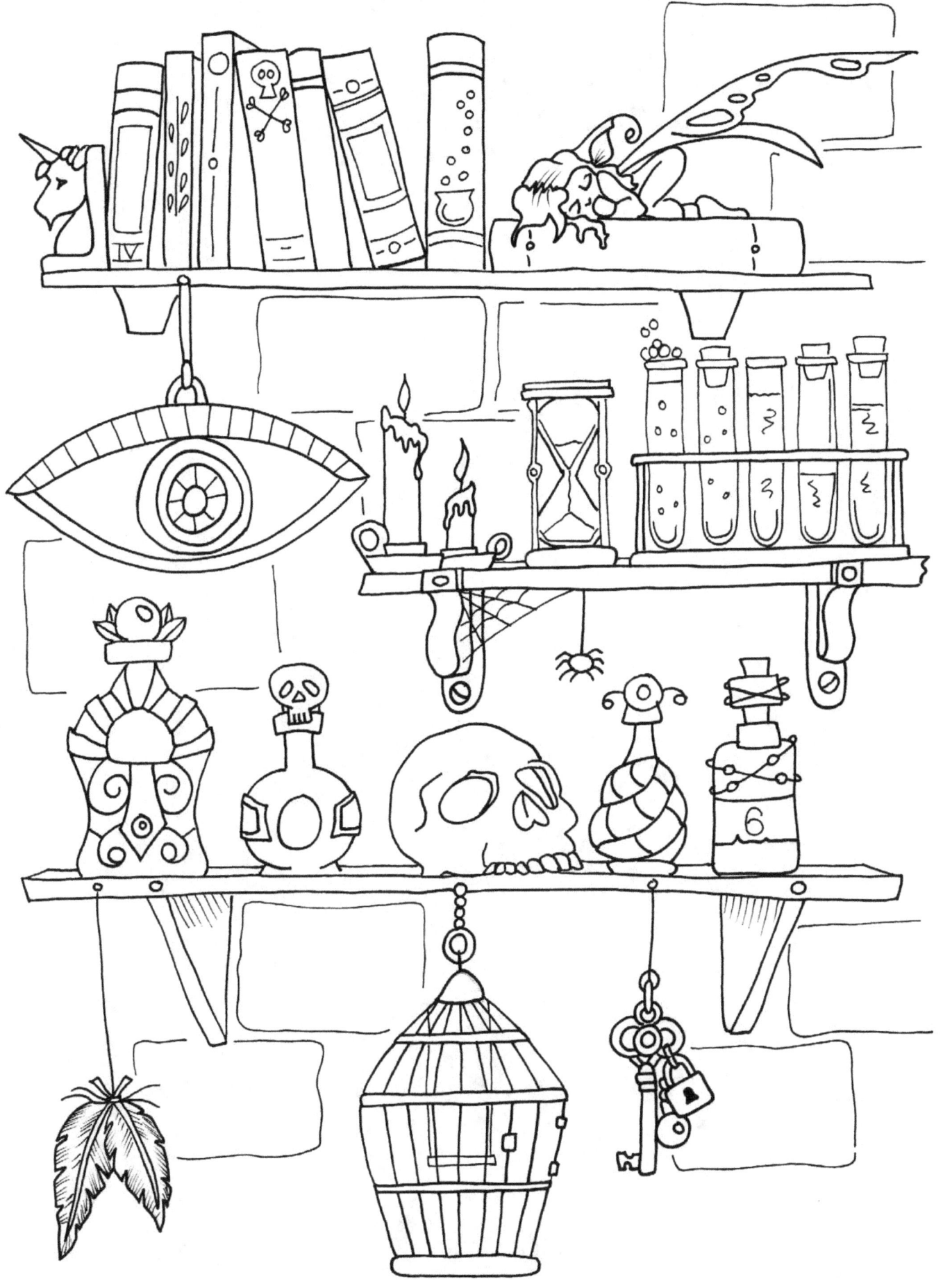

'Knick Knacks'

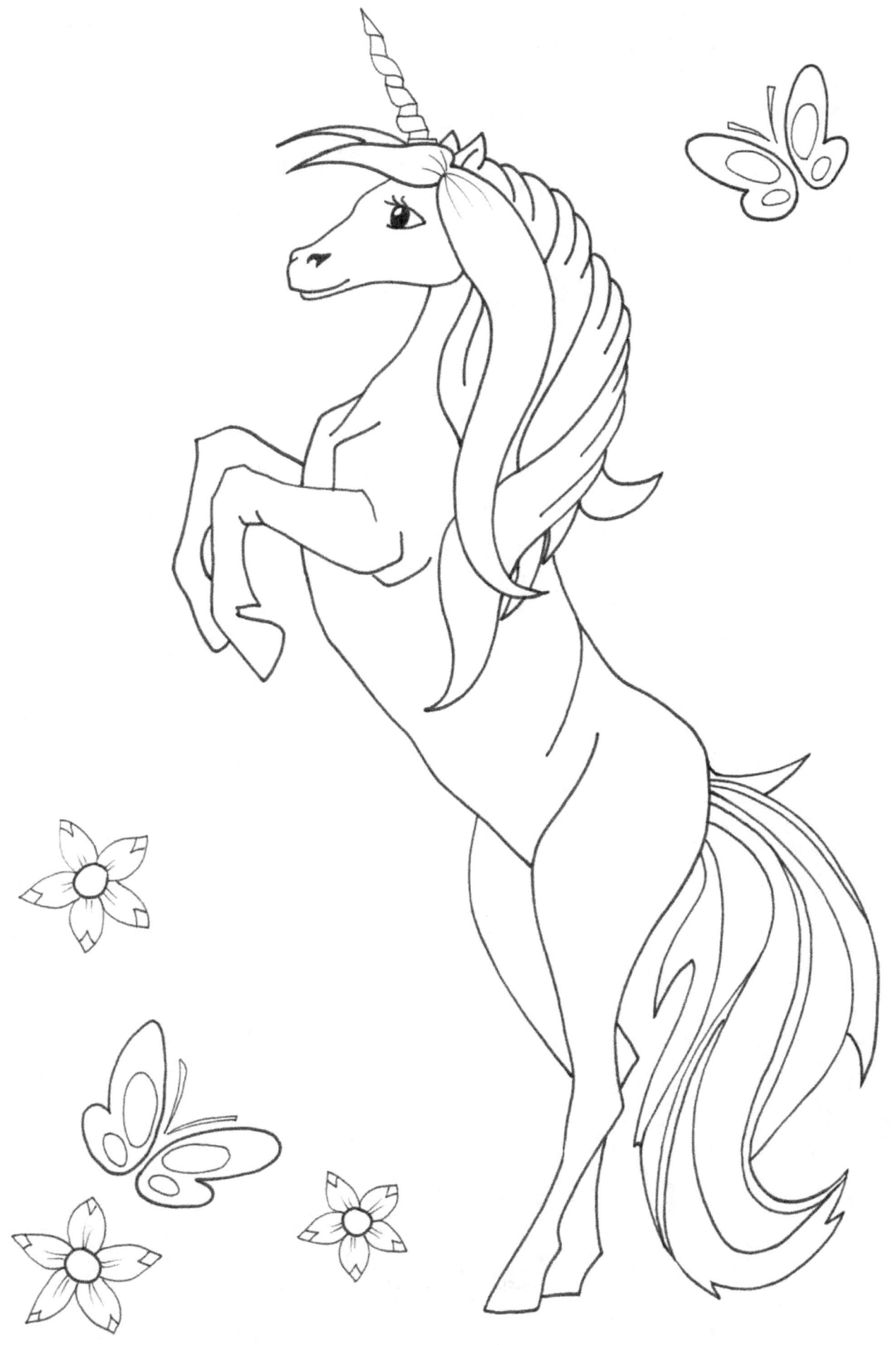

'Butterfly Dance'

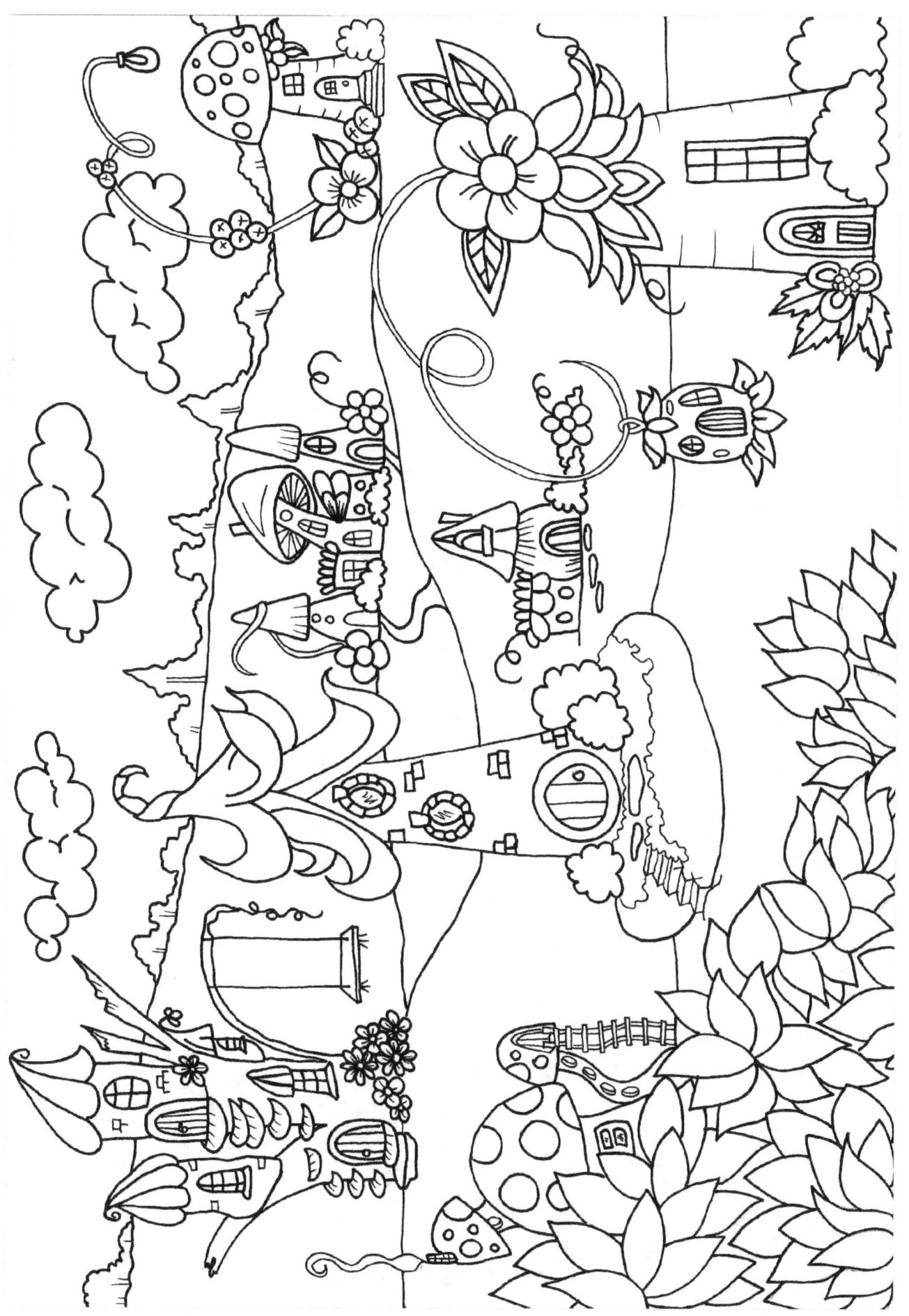

'Home Sweet Home'

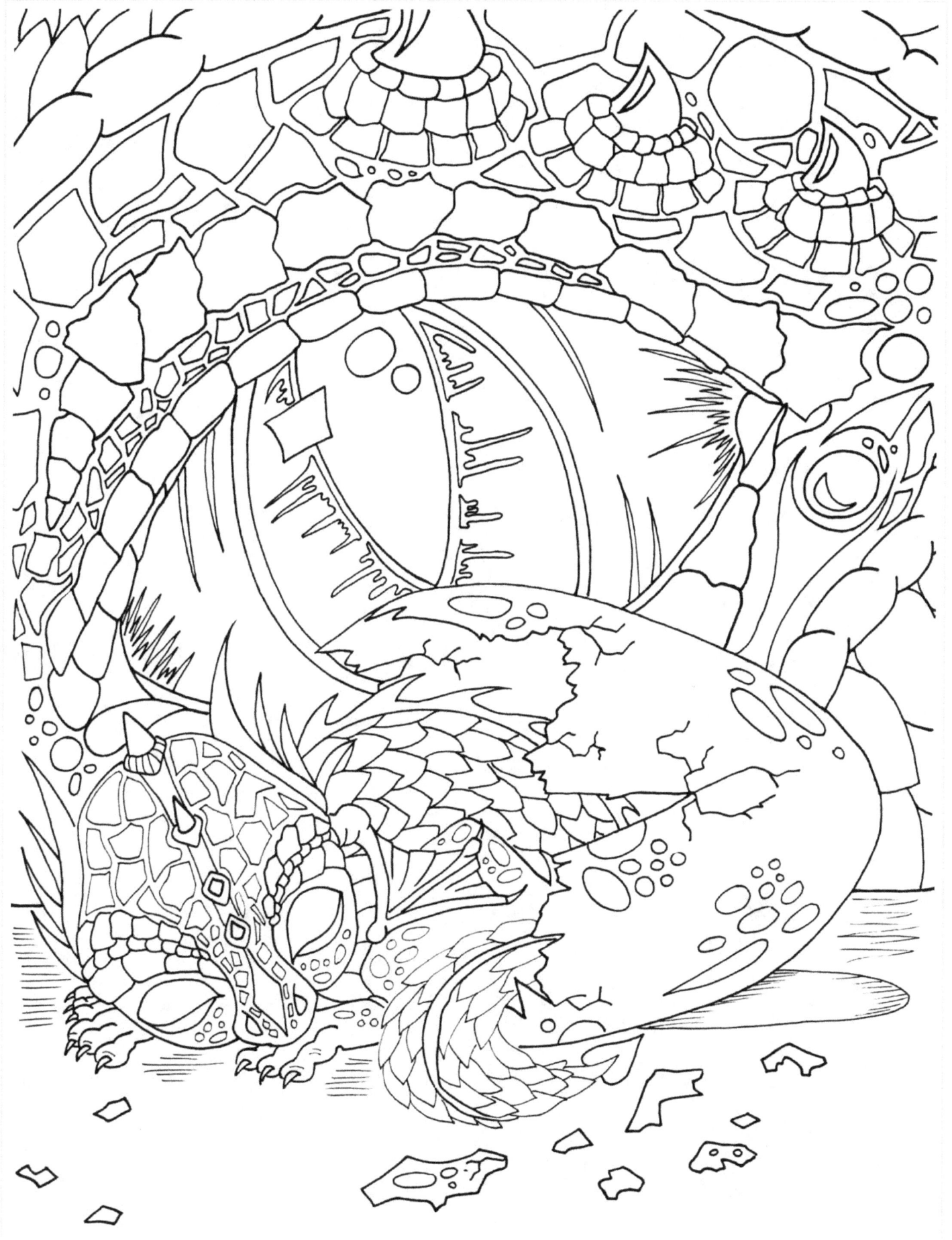

'New Baby'

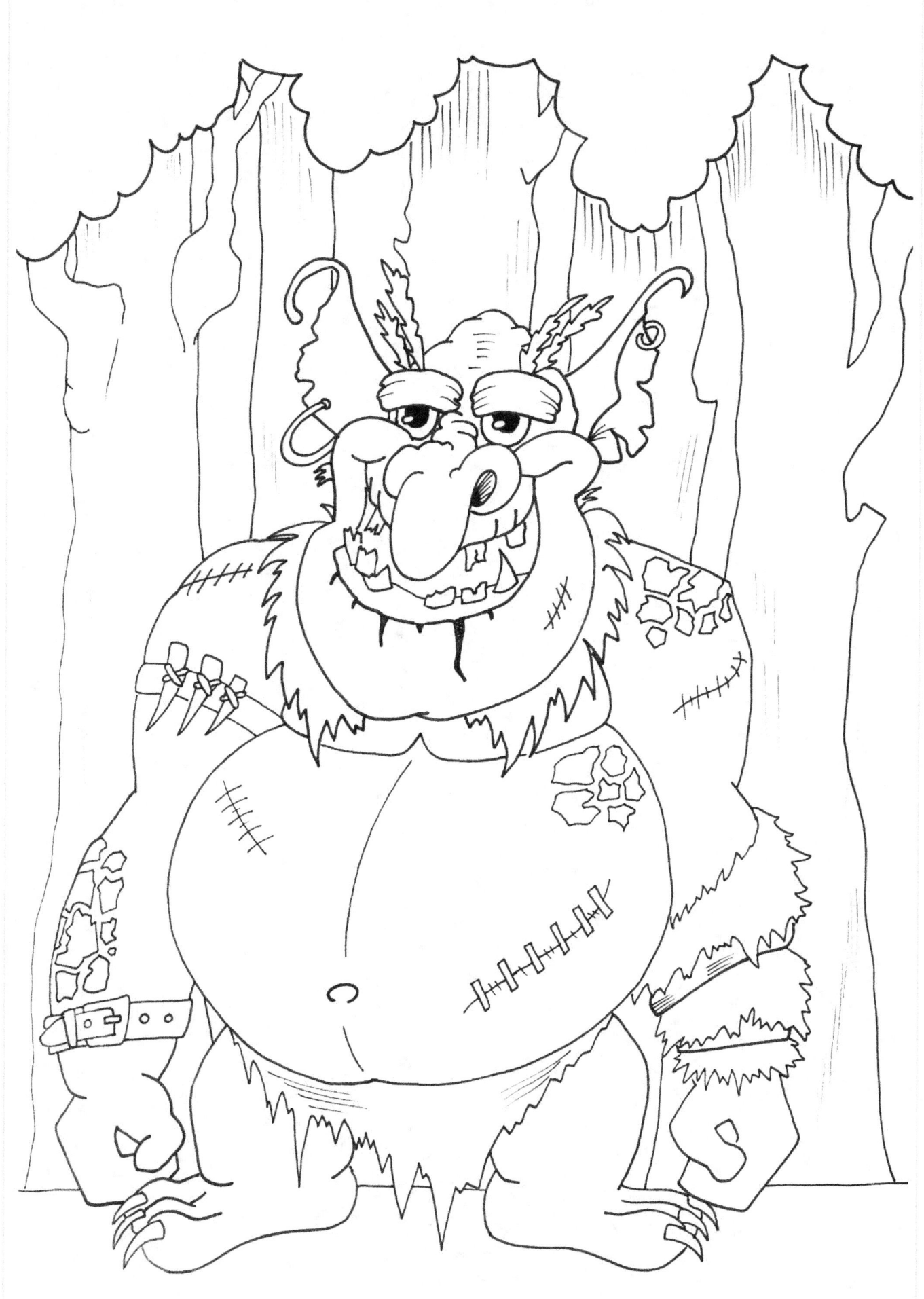

'Sherk'

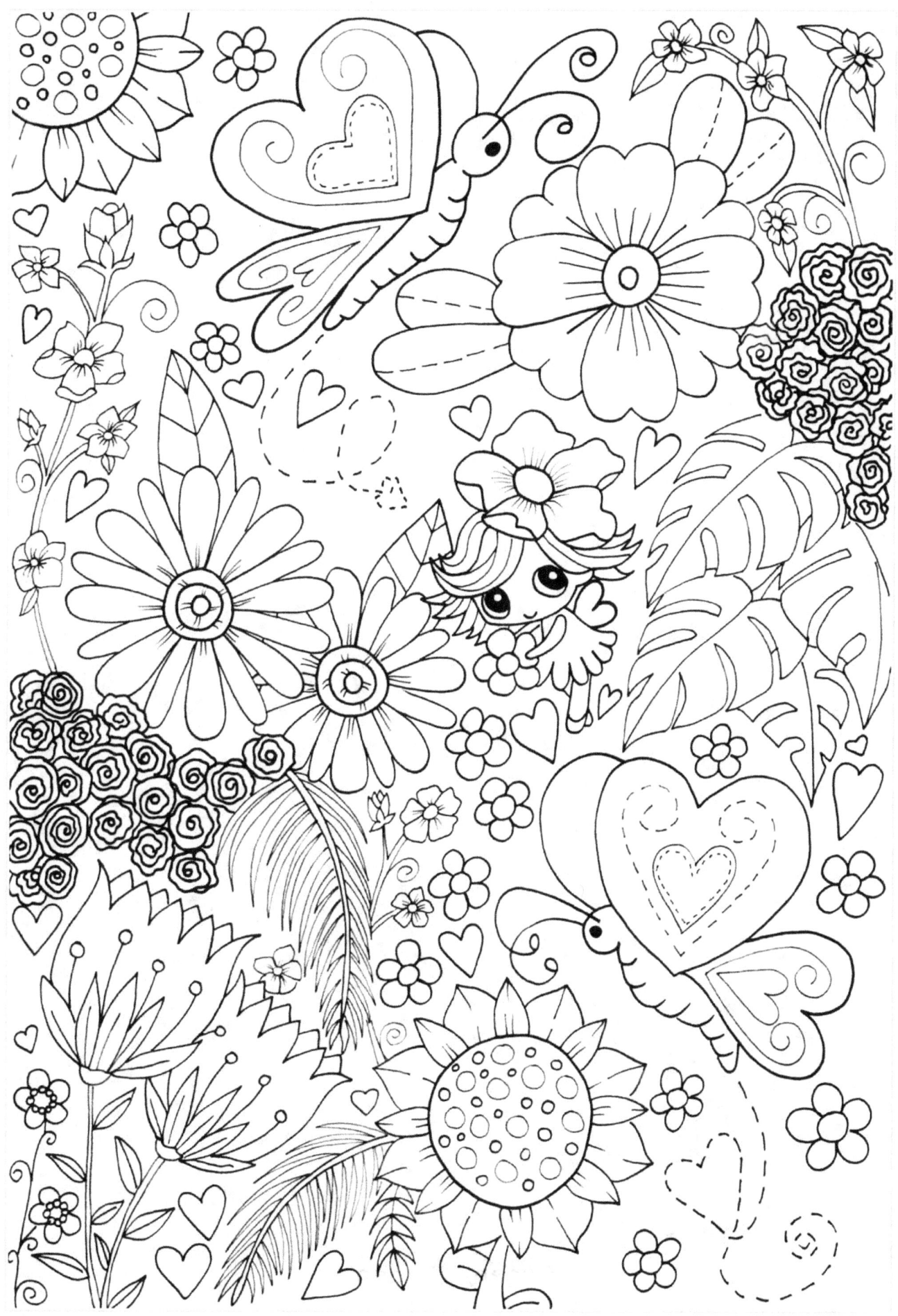

Tiegans Garden'

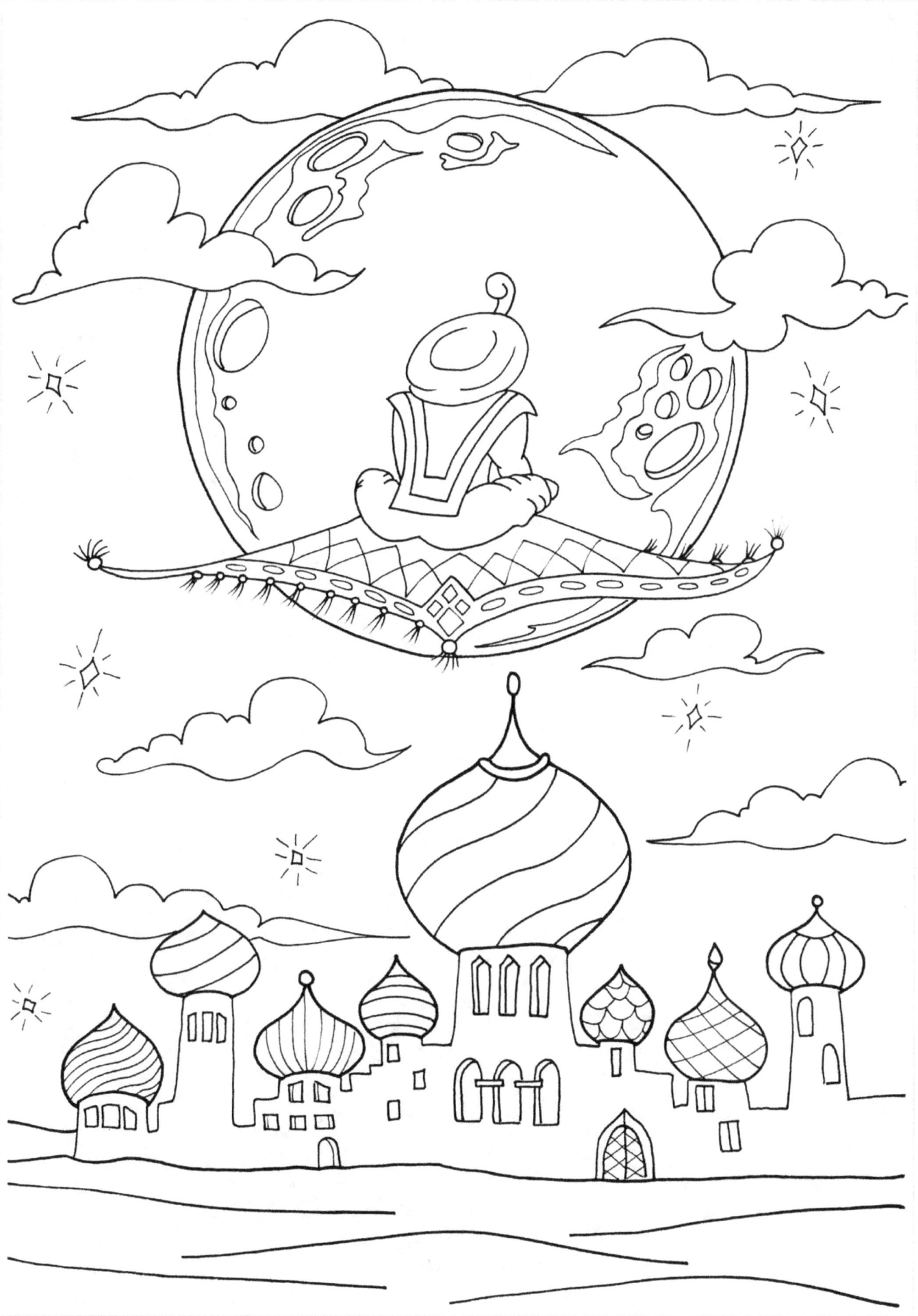

'Carpet Ride'

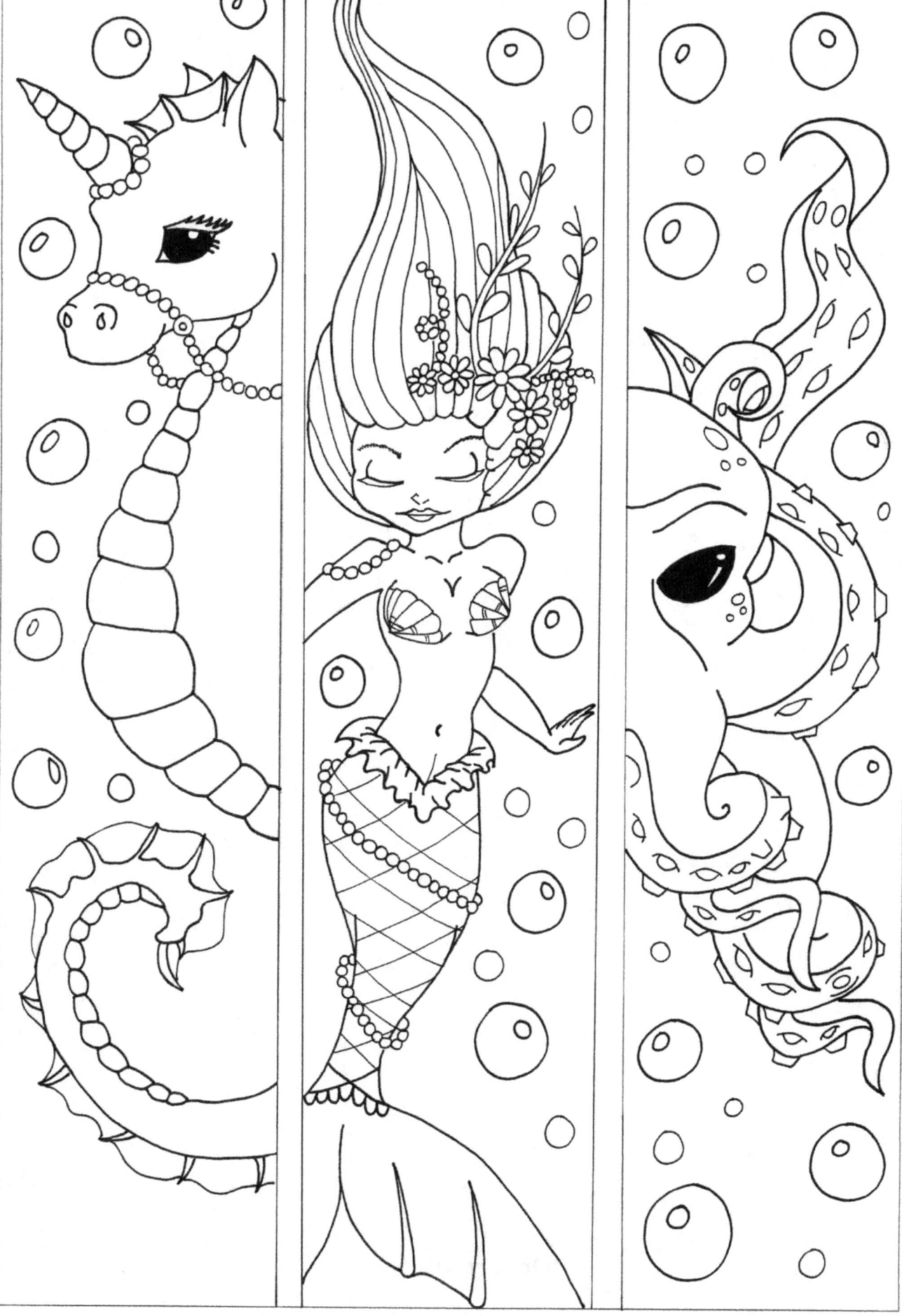

'Ocean Trio'

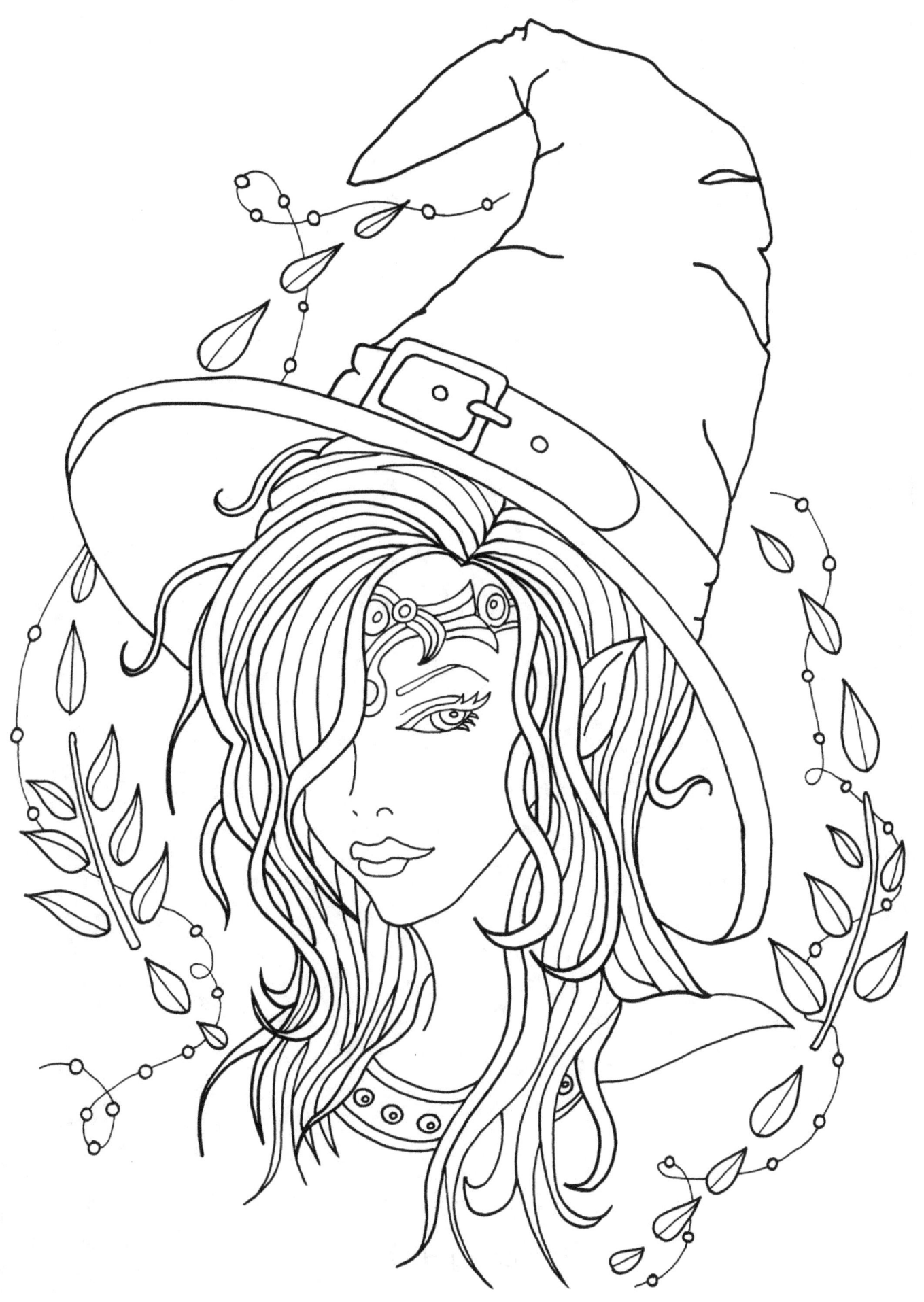

'Witching Hour'

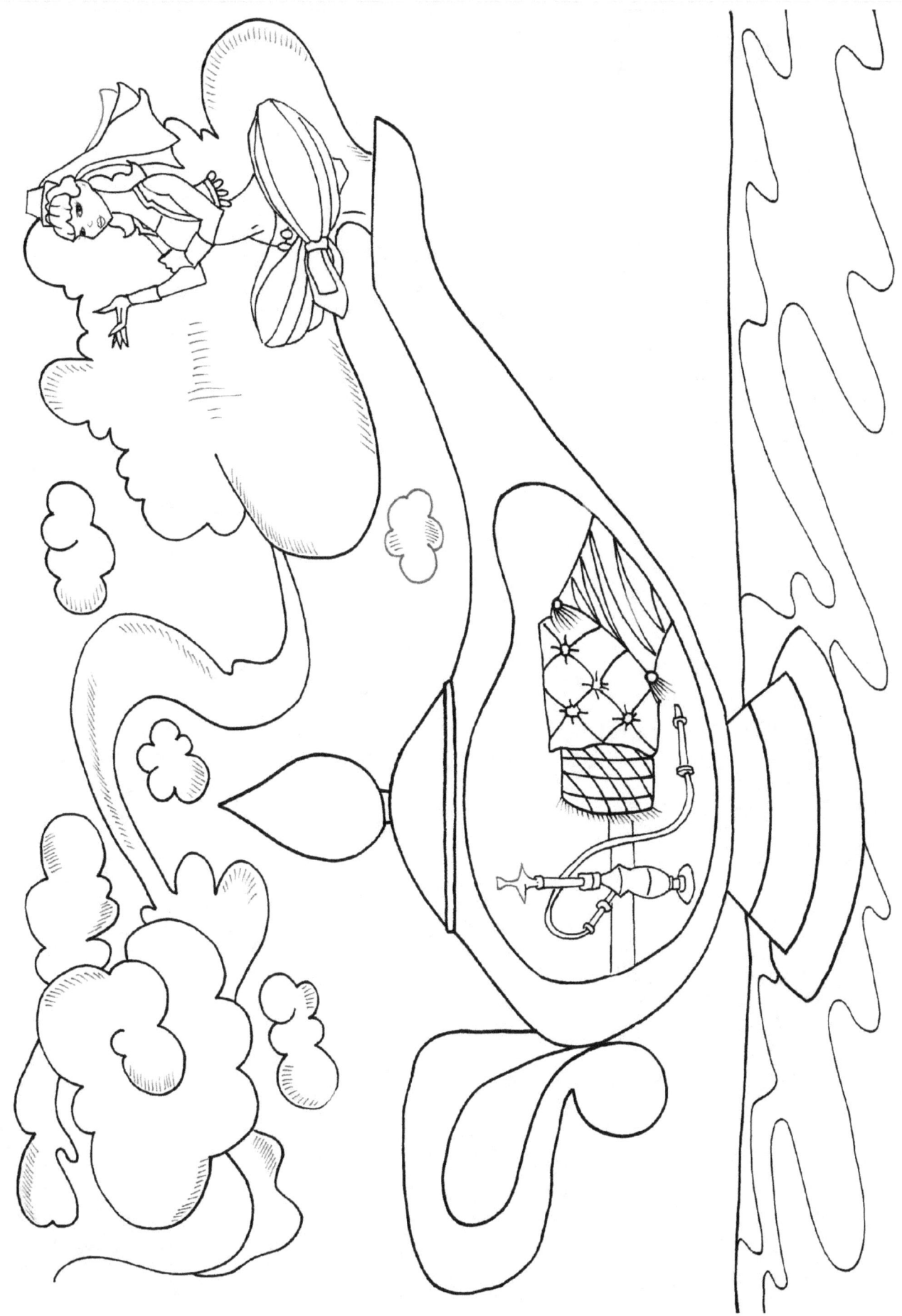

'And I Live Here!'

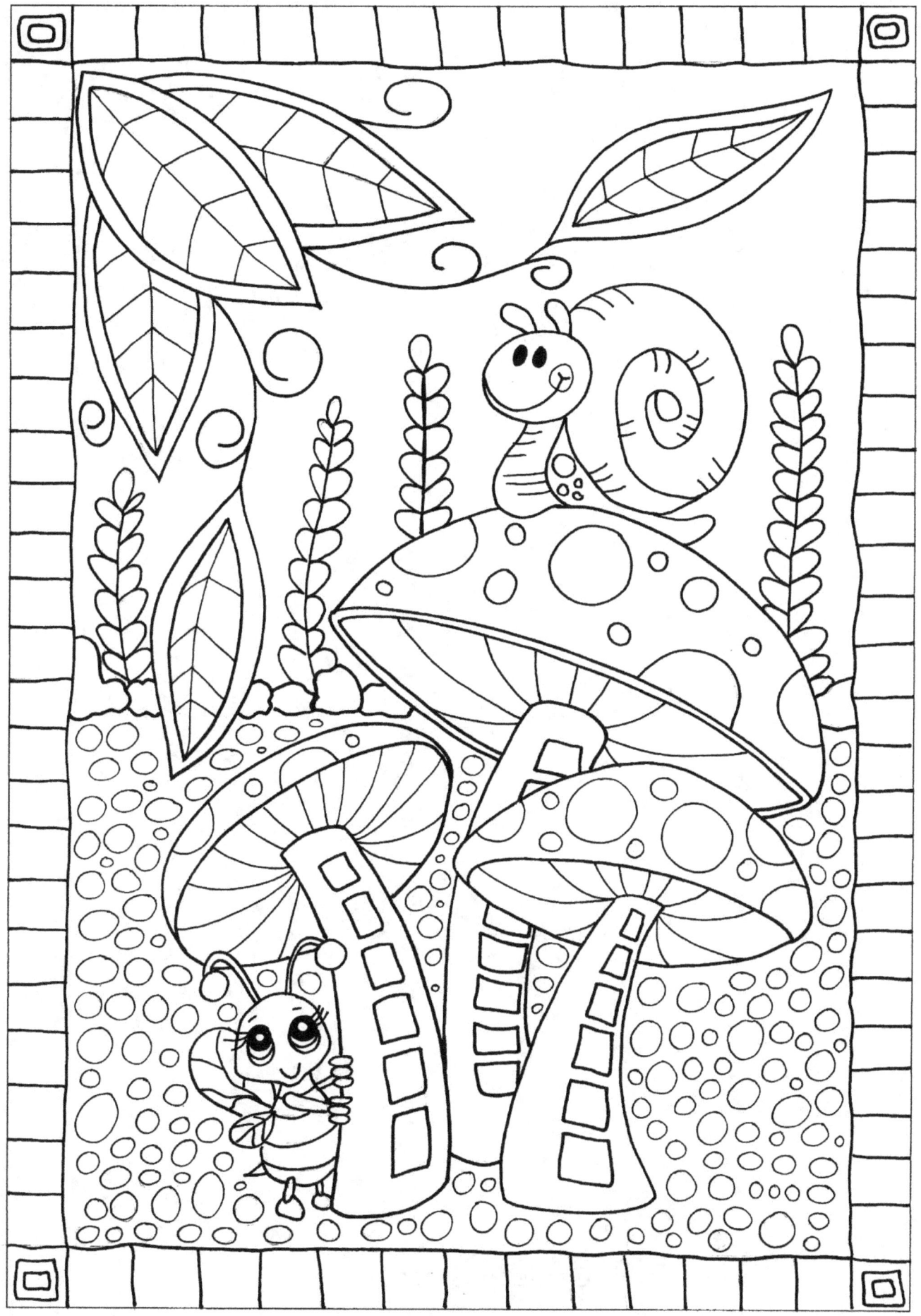

'Garden Games'

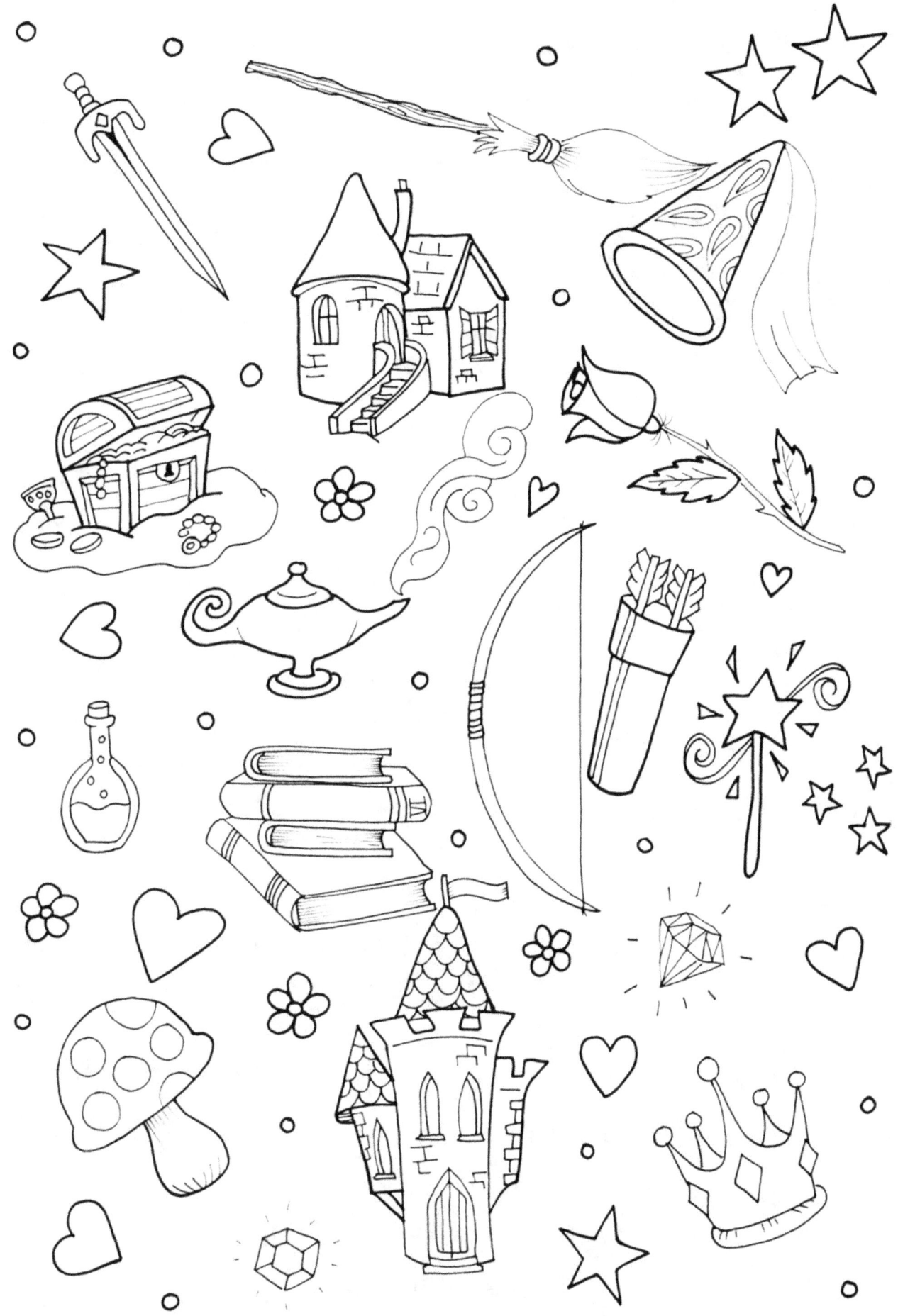

'Bibbedy Bundle'

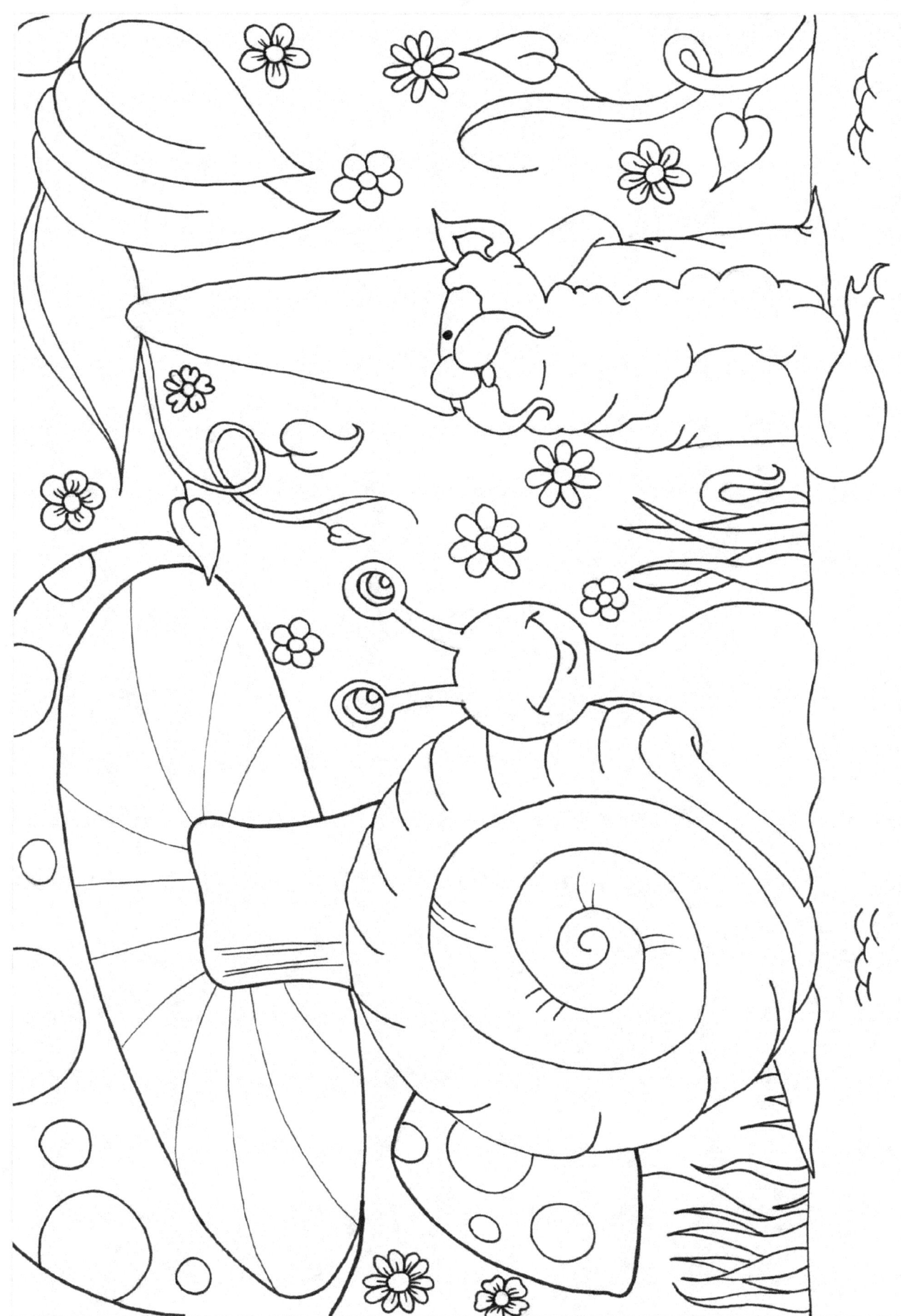

'Friends'

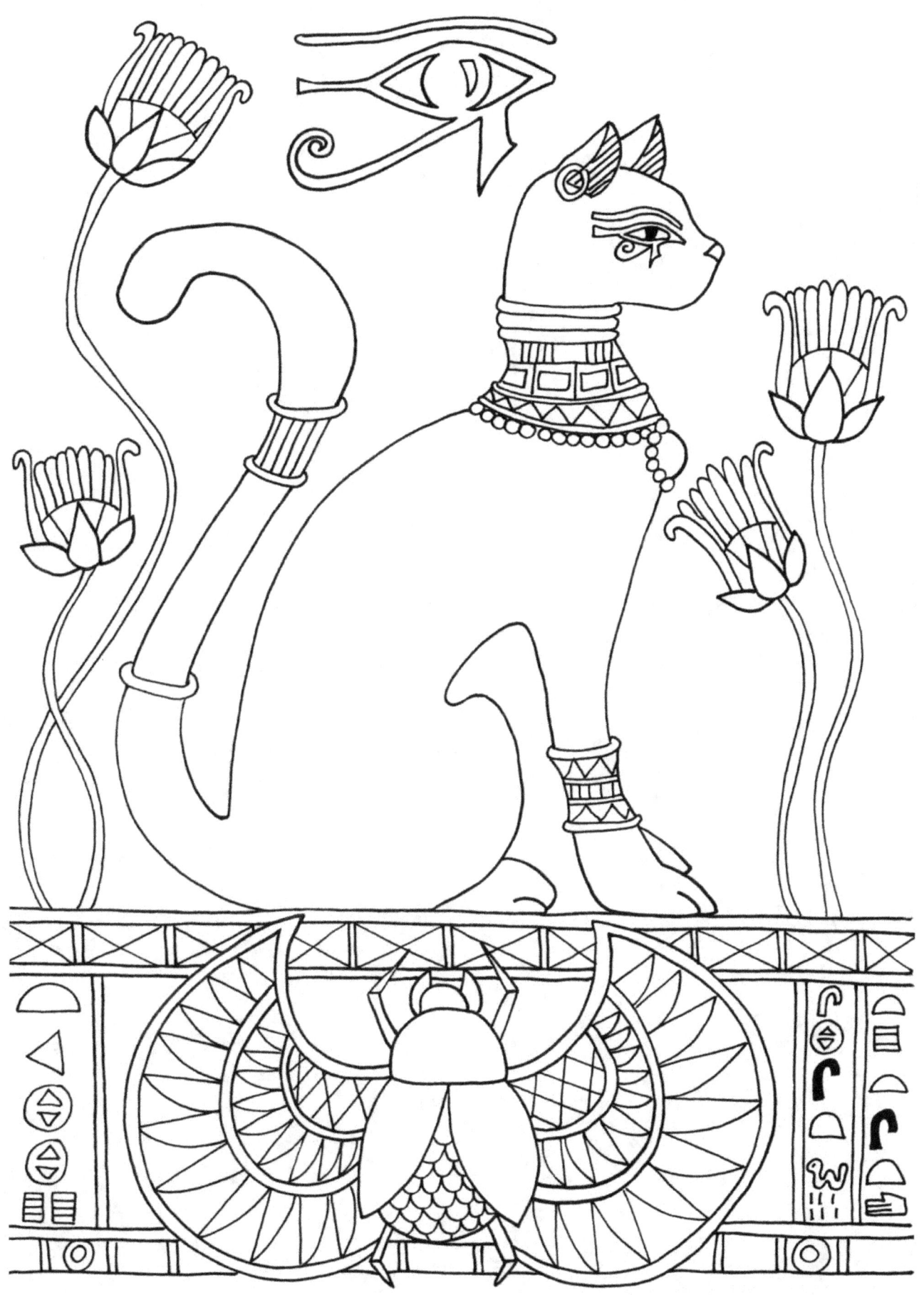

'Cats Eye'

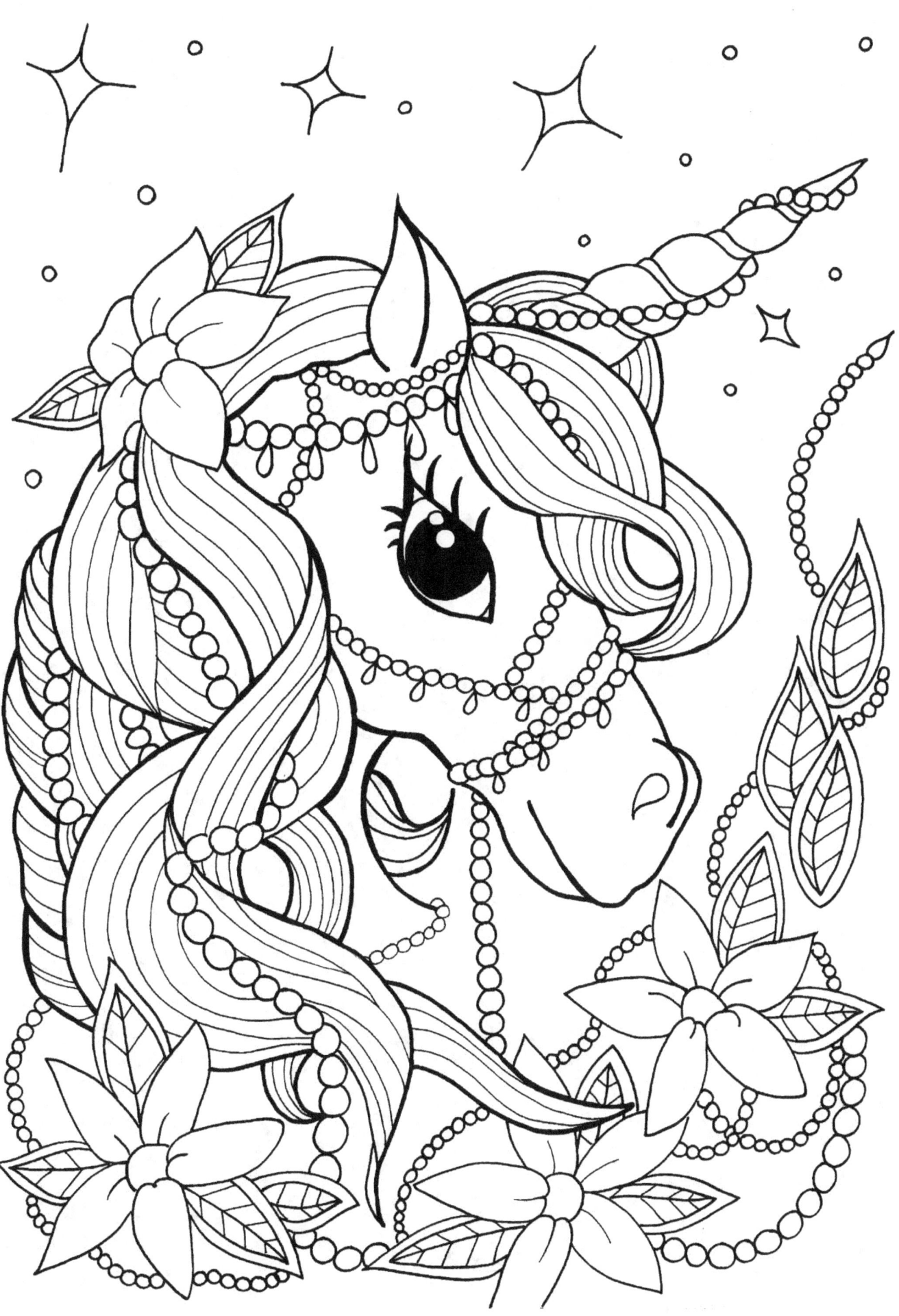

'Glamicorn'

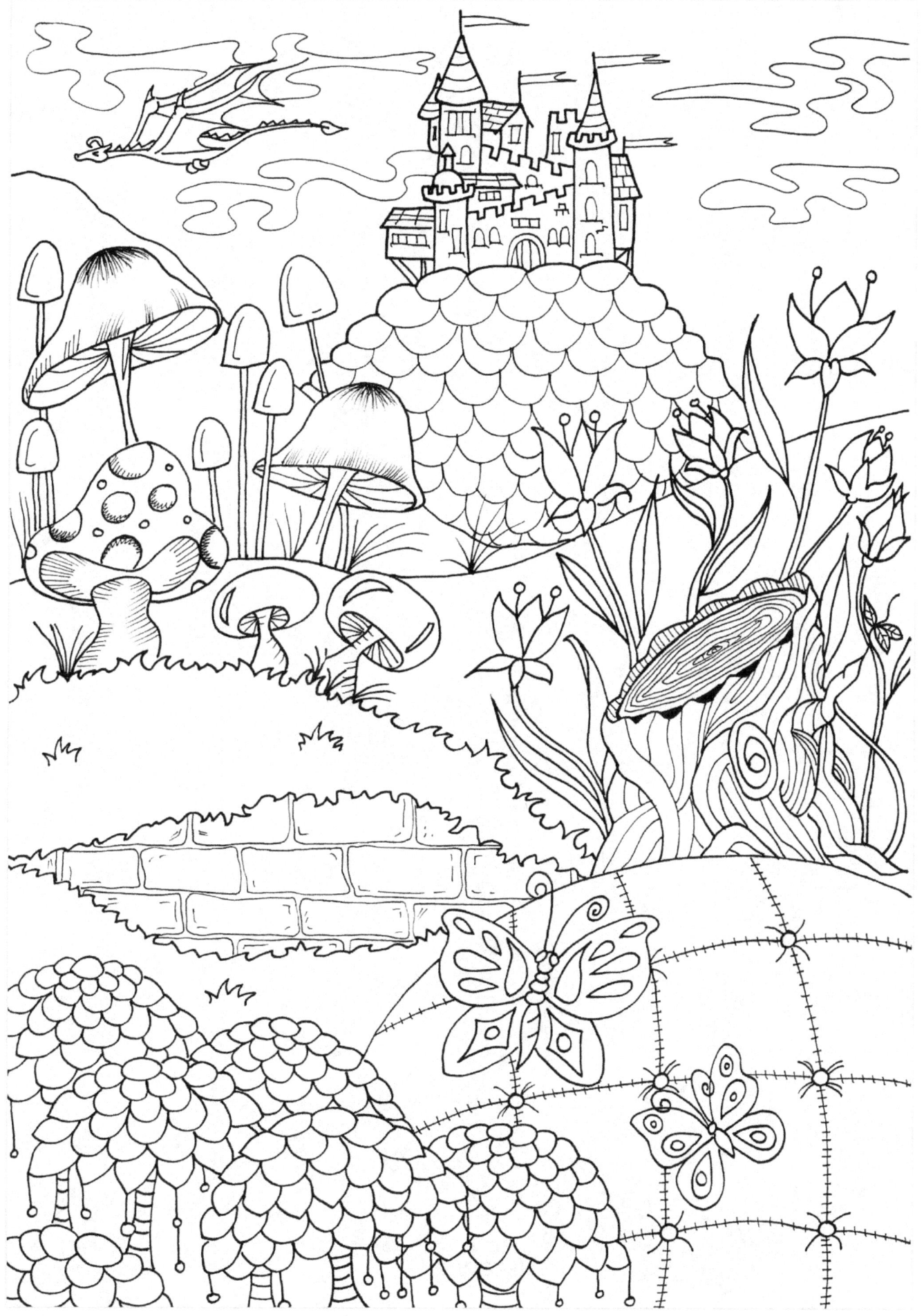

'Distance'

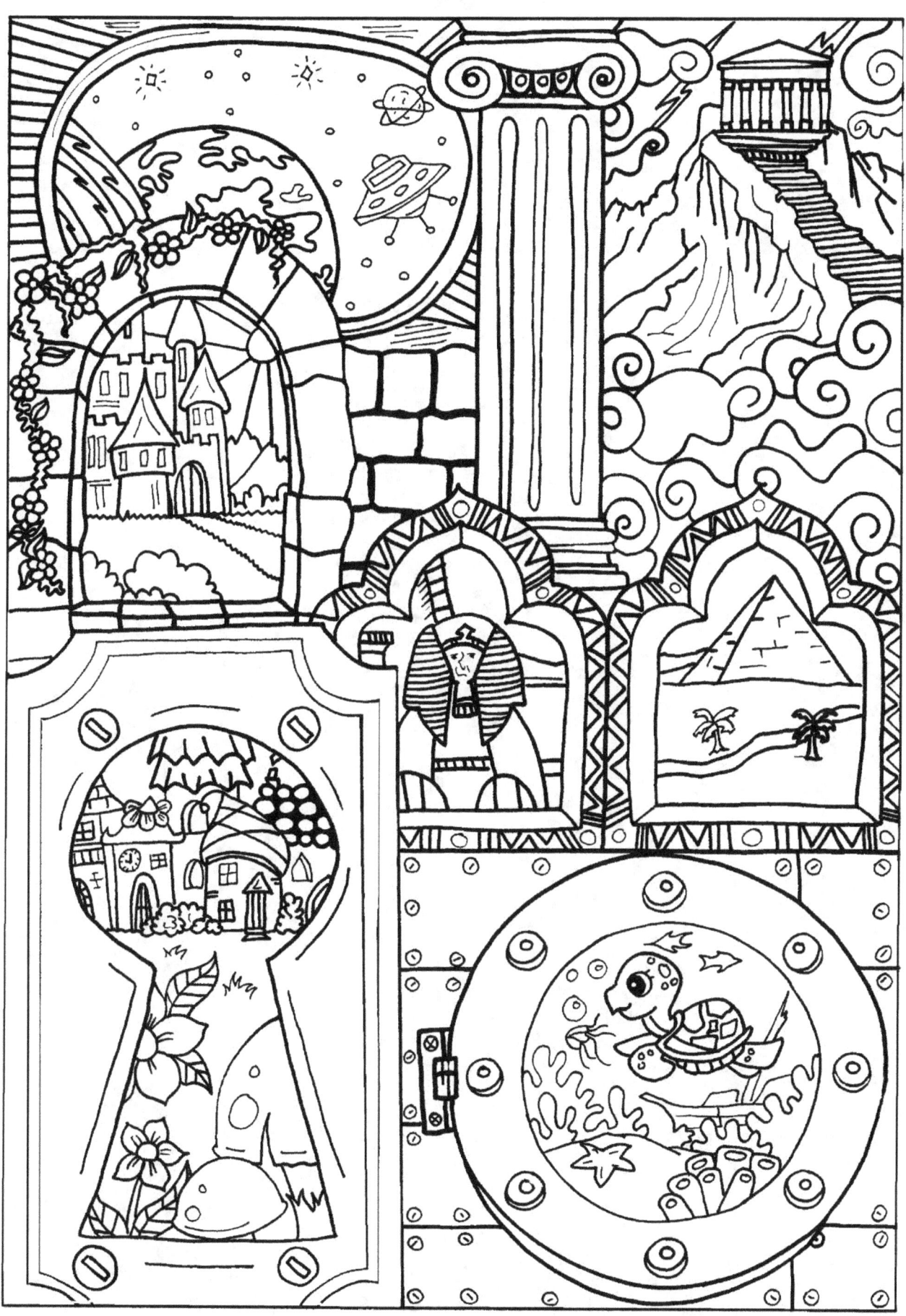

'View to the Worlds'

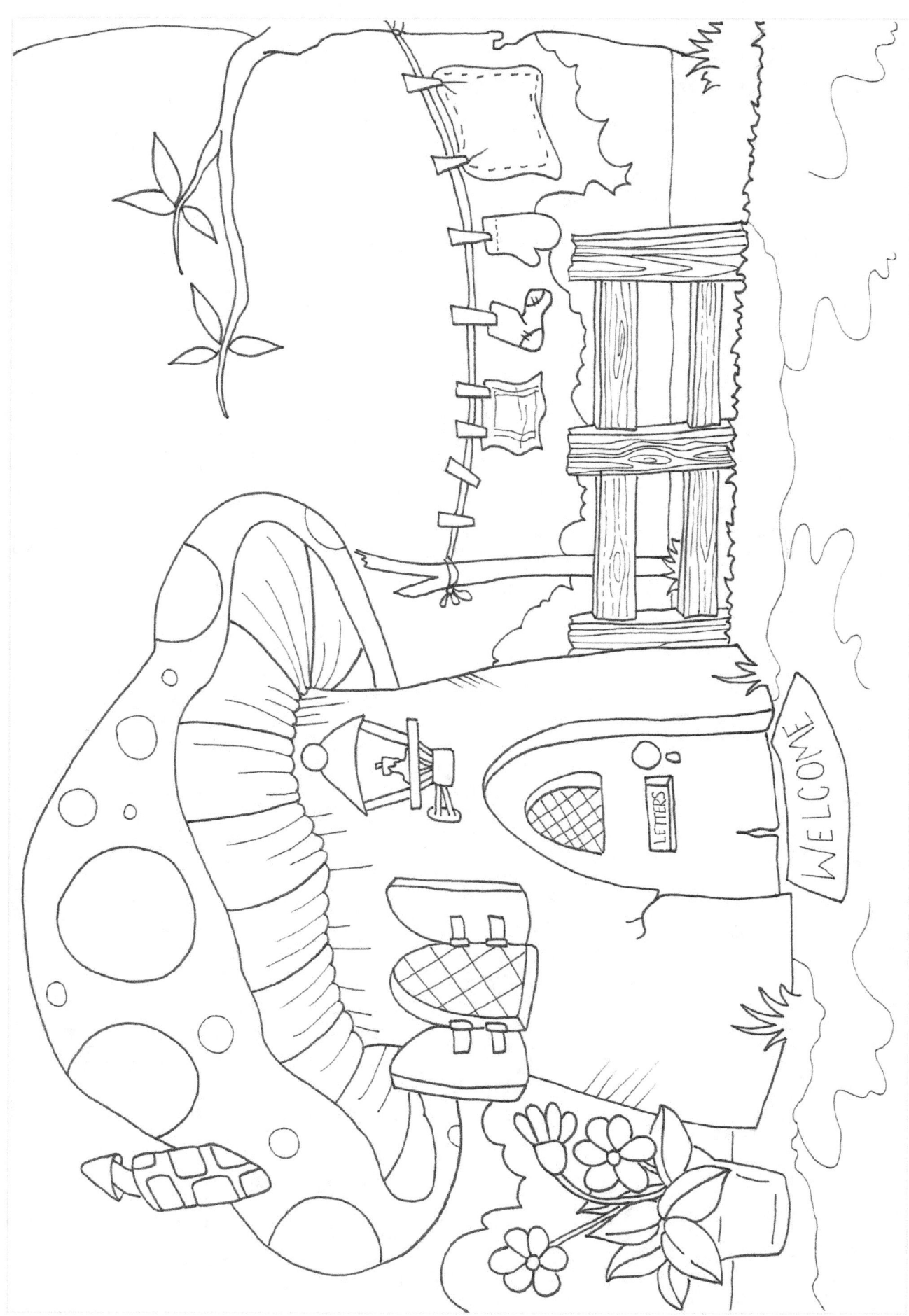

'Welcome'

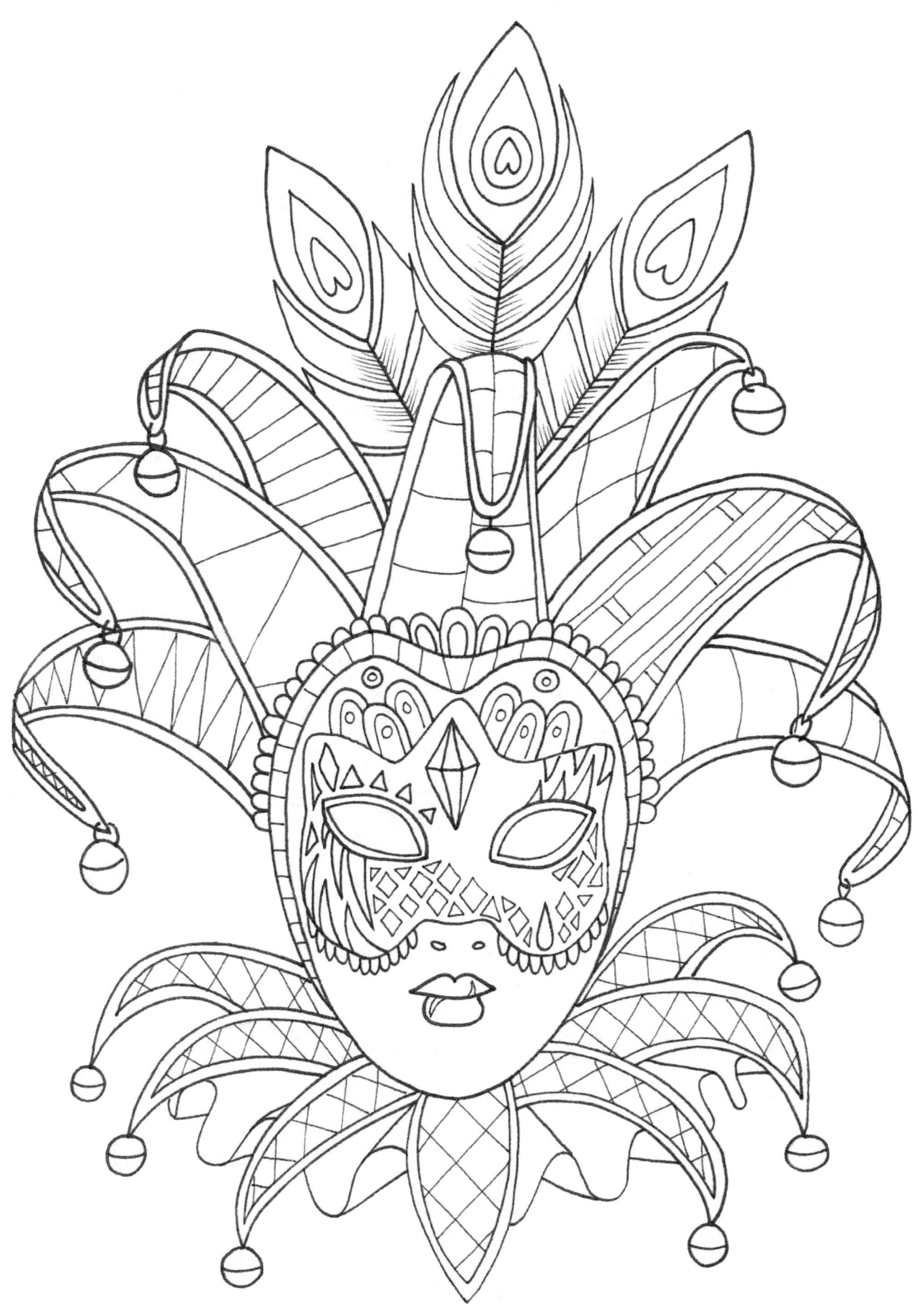

'You Jest'

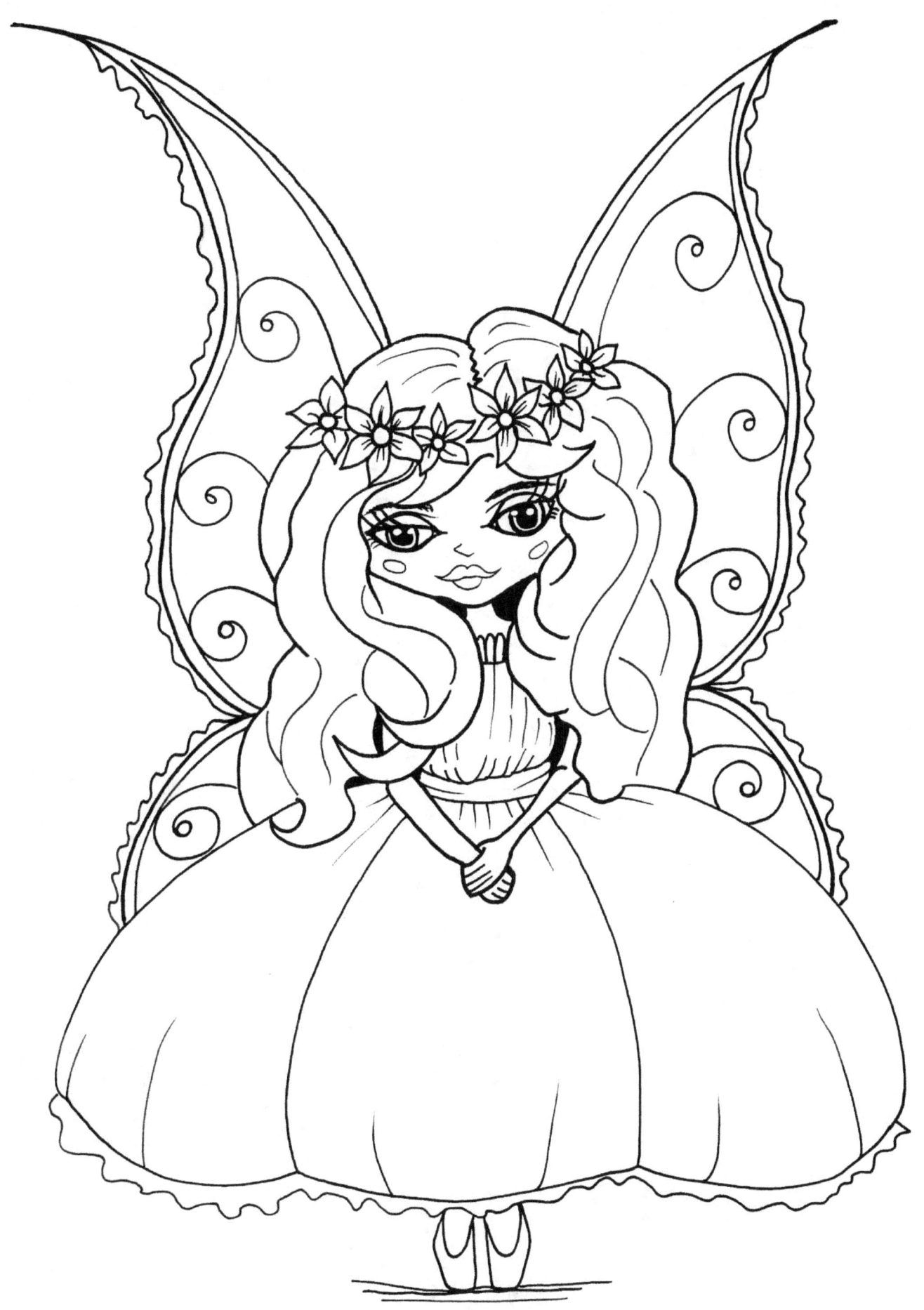

'Fairy Fae'

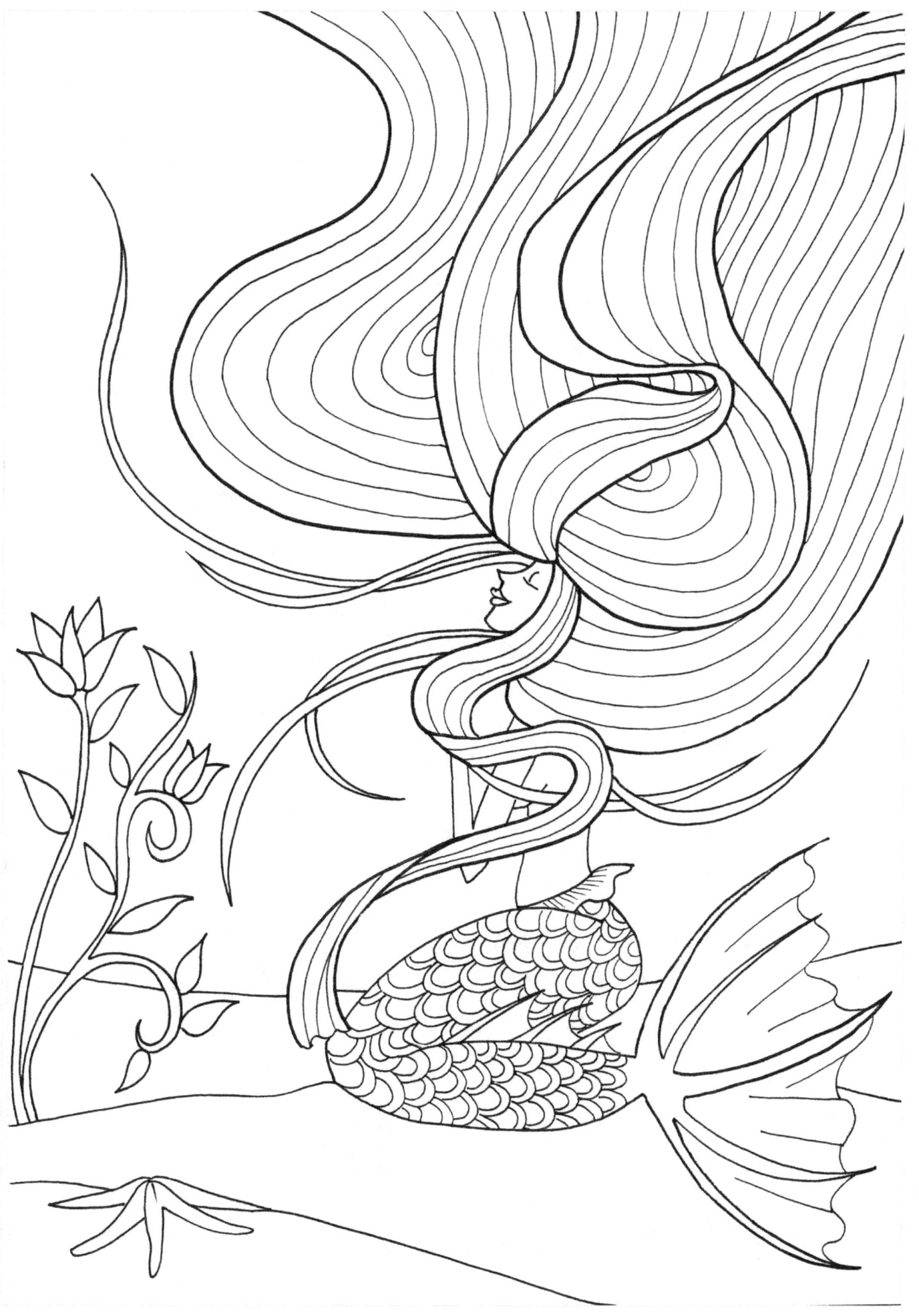

'Hairy Situation'

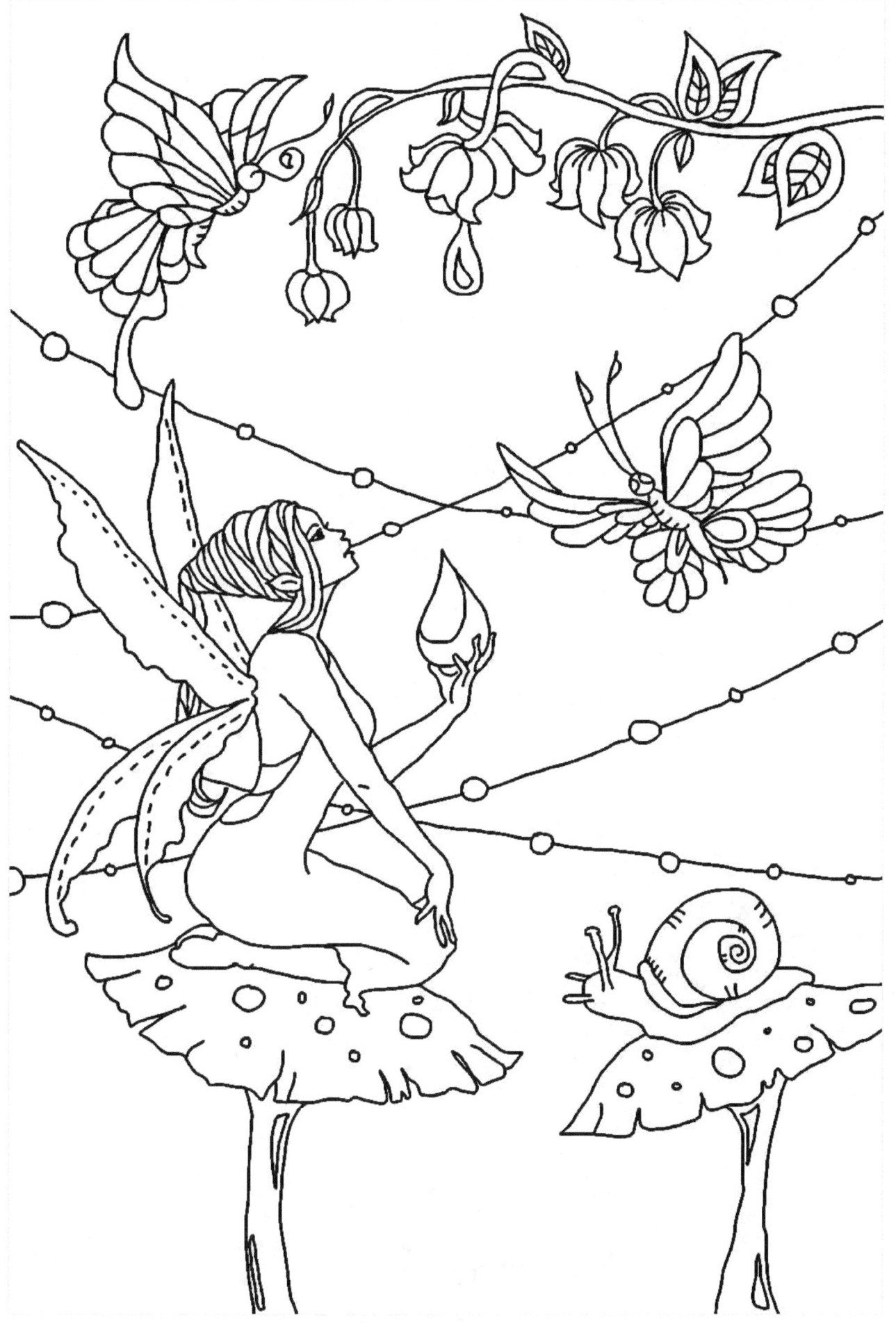

'Fairy Rain'

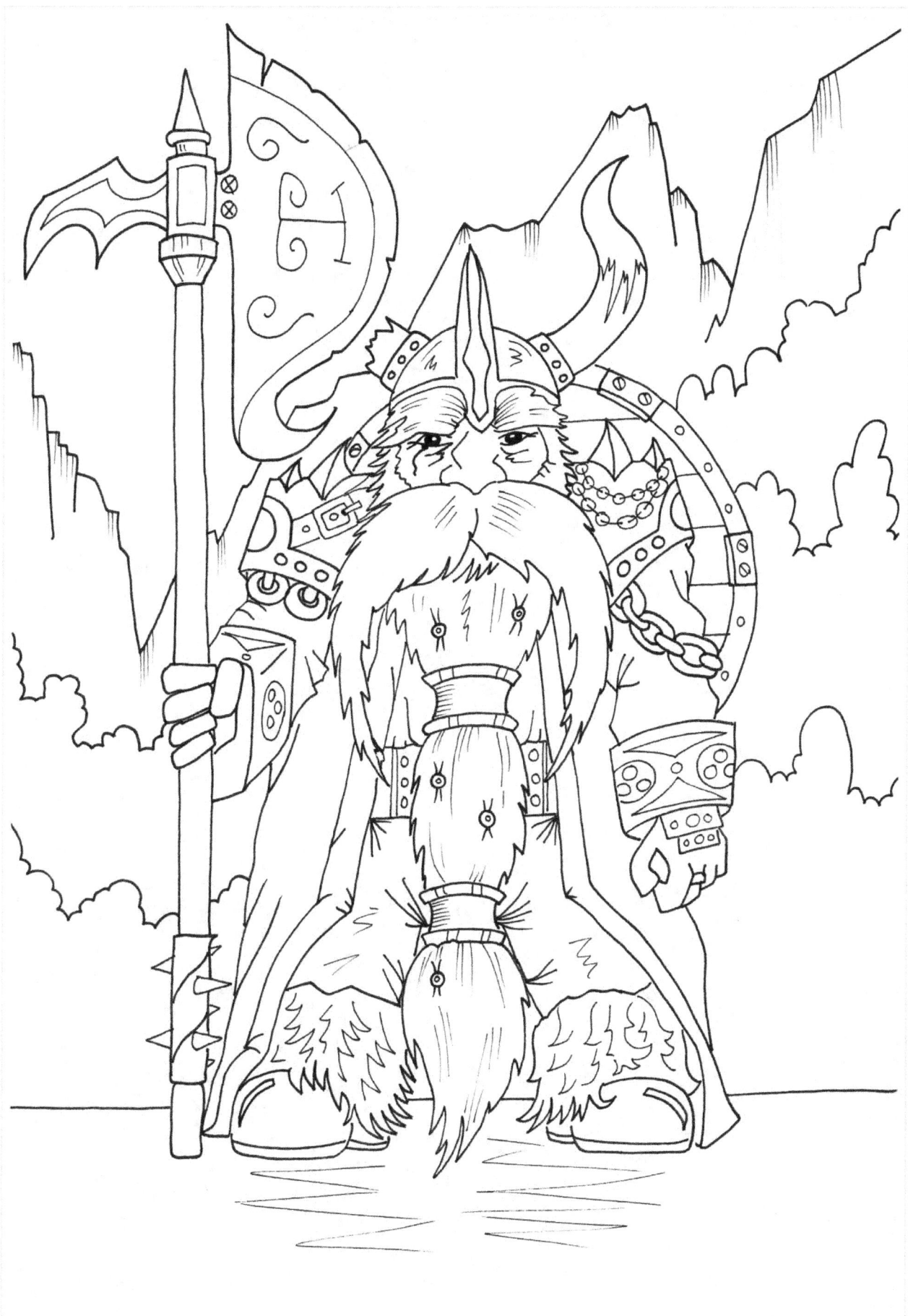

'Algarn'

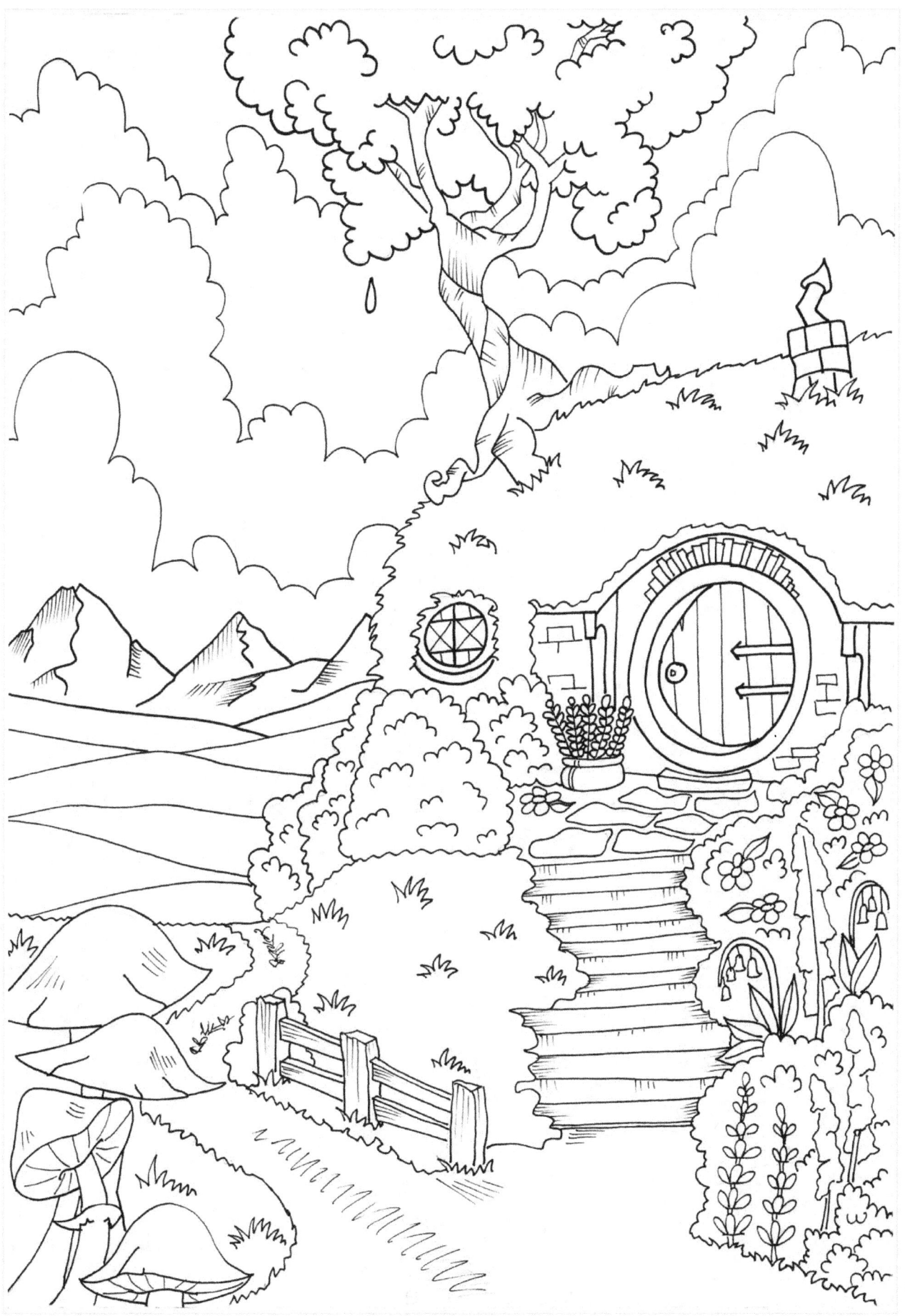

'Lets go Home'

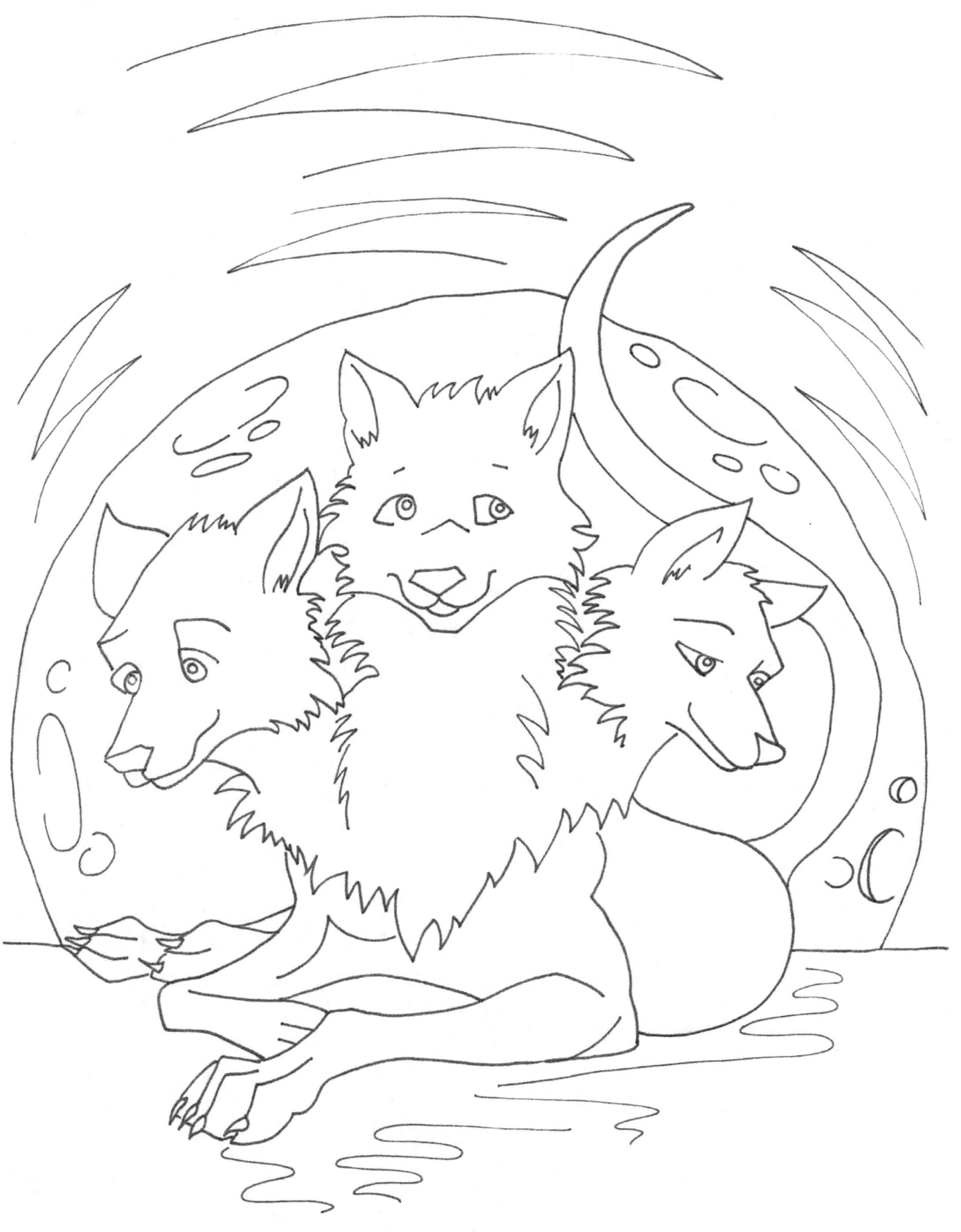

'3 Heads are better than 1'

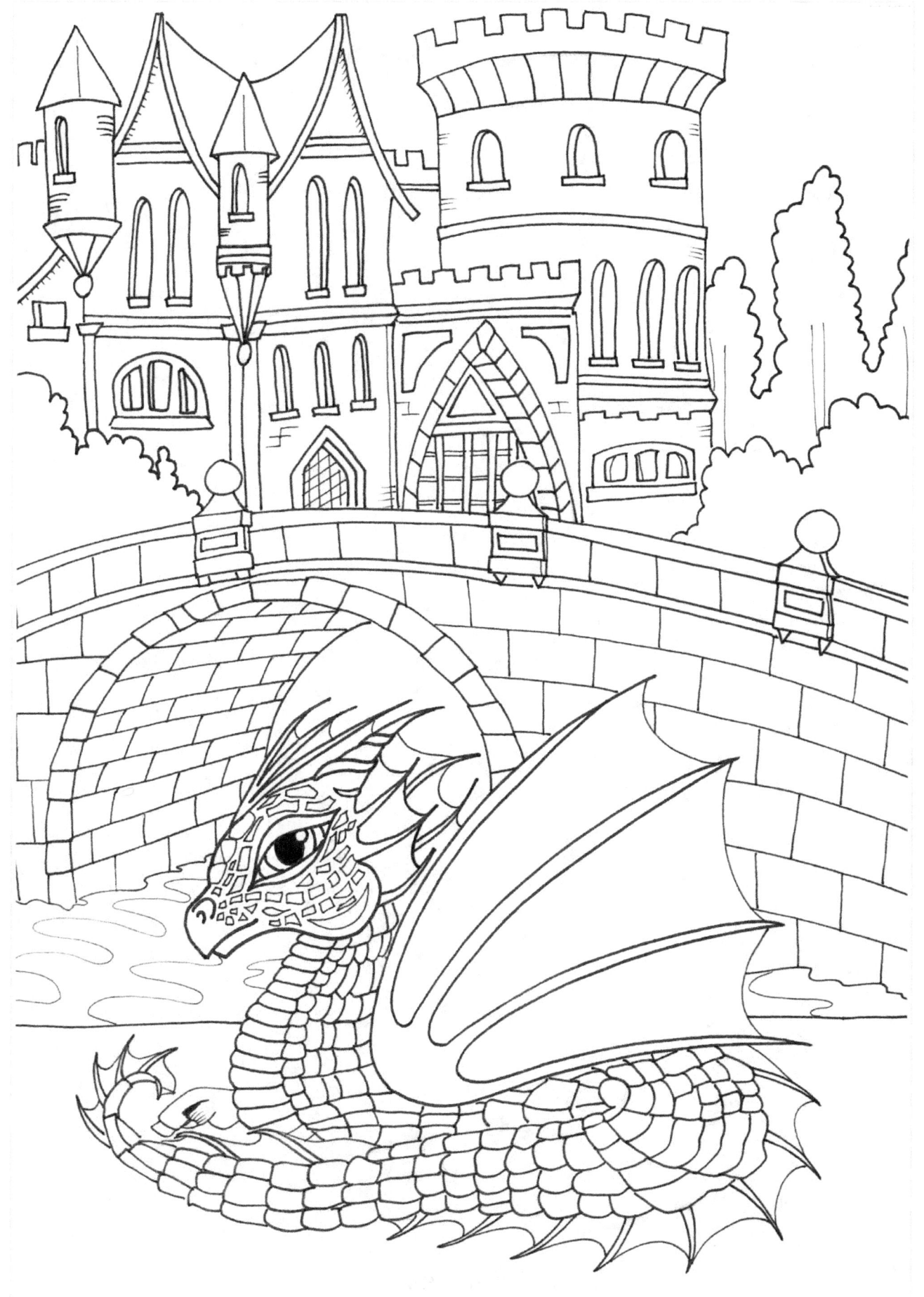

'River Rest'

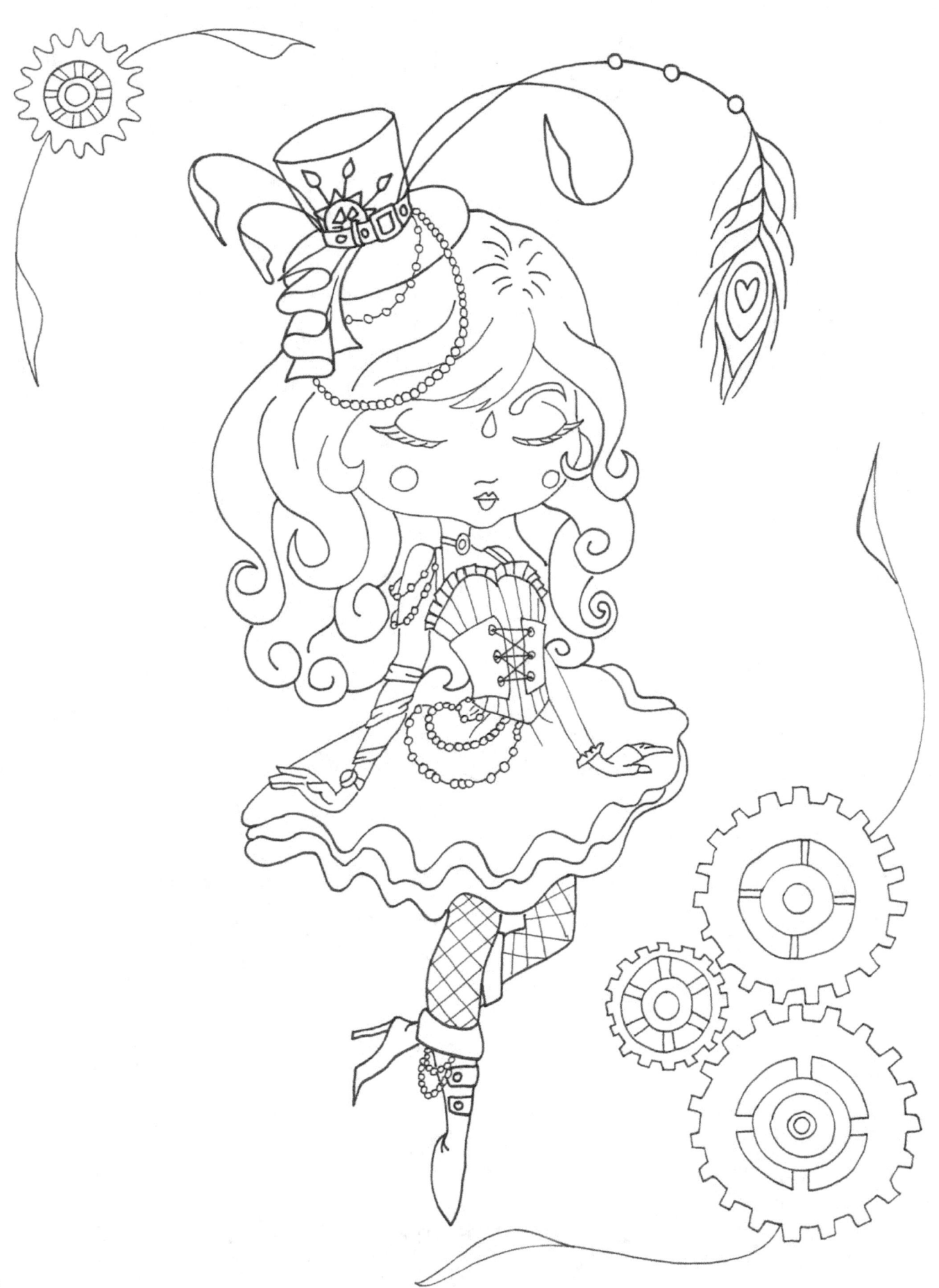

'Steamy Dreamy'

Colour Test Page